Medical Humanities Series

The Medical Humanities Series is devoted to publication of original or out-of-print materials relating to perceptions the humanities bring to clinical practice and health care. In this way, the Series also serves to promote communication between clinicians, humanists and the general public.

Several titles in the Series have been commissioned for areas in which little material is available. The following disciplines are represented in the Series: anthropology, decision-making in medicine, history, jurisprudence, literature, philosophy, religious studies and visual arts. Unsolicited manuscripts will be considered.

The Series is a project of The Department of Medical Humanities at Southern Illinois University School of Medicine in Springfield.

THE VISUAL ARTS AND MEDICAL EDUCATION

Edited by Geri Berg

with Eric Avery

John Burnside

John Cody

Charles Rusch

W. Sherwin Simmons

E. A. Vastyan

Bernice Wenzel

SOUTHERN ILLINOIS UNIVERSITY PRESS
CARBONDALE AND EDWARDSVILLE

Published by Southern Illinois University Press in cooperation with the Institute on Human Values in Medicine of the Society for Health and Human Values.

This is Report #16 of the Institute on Human Values in Medicine, funded by a grant from the National Endowment for the Humanities.

"The Arts Versus Angus Duer, M.D.," by John Cody, originally appeared in Donnie J. Self, *The Role of the Humanities in Medical Education* (Norfolk: Teague and Little, Inc., 1978, pp. 45–61), in a slightly different form. Reprinted by permission of the Bio-Ethics Program of Eastern Virginia Medical School.

Camille on Her Death Bed, by Claude Monet, reproduced by permission of Clichés Musées Nationaux, Paris, and © SPADEM, Paris/VAGA, New York.

The illustrations in "Hands Healing: A Photographic Essay" are owned by Eric Avery, who also holds the copyright.

The Maids of Honor, by Diego Velázquez, copyright © Museo del Prado, Madrid. All rights reserved. Total or partial reproduction prohibited.

Napoleon Visiting the Pesthouse at Jaffa, by Baron Antoine-Jean Gros, reproduced by permission of Clichés Musées Nationaux, Paris.

Library of Congress Cataloging in Publication Data

Main entry under title:

The Visual arts and medical education.

(Report nr. 16 of the Institute on Human Values in Medicine) (Medical humanities series)
 1. Medical education. 2. Medicine and art.
I. Berg, Geri, 1946– . II. Avery, Eric.
III. Series: Report of the Institute on Human Values in Medicine ; nr. 16. IV. Series: Medical humanities series. [DNLM: 1. Education, Medical. 2. Medicine in art. W1 RE209CQ no.16 / WZ 330 V834]
R737.V53 1983 610'.7 82-19217
ISBN 0-8093-1038-4

86 85 84 83 4 3 2 1

Contents

Illustrations

Foreword

Visual Awareness:
The Visual Arts and the Clinician's Craft

Edmund D. Pellegrino, M.D.

The clinician's craft begins with the eye—his essential diagnostic tool. With it he heeds the Hippocratic admonition to observe and to read the signs of illness impressed on the face and body of his patient.

The artist's craft also begins with the eye. With it he records the work of nature and man's work upon nature. Like the physician the artist studies faces, forms, and colors.

Clinician and artist are united in their need for a special visual awareness. Each sees; but for each, sight must transcend appearances. As Paul Klee puts it: "Art does not render the visible; it makes visible." The clinician must penetrate beneath the images to comprehend what ails his patient; the artist must penetrate beyond color, form, and context to see in new and imaginative ways.

The need for a special state of visual awareness binds the good artist and the good clinician. It brings each closer to a special truthfulness. In Willa Cather's words: "Artistic growth is more than anything else a refining of the sense of truthfulness."

This book reports on a series of dialogues between health professionals and artists held over a period of a year and a half under auspices of the Institute on Human Values in Medicine. It is one in a series of "dialogues between the disciplines" designed to examine the intersections of the humanities with medicine, particularly in

relation to the education of today's physicians. Other dialogues published are *Nourishing the Humanistic in Medicine: Interactions with the Social Sciences,* edited by William R. Rogers and David Barnard (Pittsburgh: University of Pittsburgh Press, 1979); *Medicine and Religion: Strategies of Care,* edited by Donald W. Shriver, Jr. (Pittsburgh: University of Pittsburgh Press, 1980); and *Healing Arts in Dialogue: Medicine and Literature,* edited by Joanne Trautmann (Carbondale: Southern Illinois University Press, 1981).

The education of physicians has much to gain by a closer converse with the visual arts. Illness is announced in subtle nuances of color, hue, physiognomy, gait, mannerism, gesture, tremor, form, and function—all visible to the eye but needing to be penetrated for meaning. Understanding how the artist uses his eye will enhance the physician's use of his own. Understanding the way artists of the past and present have portrayed the realities with which the physician deals should heighten the physician's visual awareness.

The artist of course directly assists physicians by his graphic depictions of anatomy, operative procedure, or pathological entity. The artist can, in two and three dimensions, reveal nuances of form and function that even the modern techniques of photography, fiber optics, and stereoscopic studies cannot fully reveal. The capacities of the physician's eye are extended manifold by exciting new technological devices like films, fiber optics, CAT scanning, and the like. But the artist's eye is still needed, as Klee suggested, to "make visible," to go beyond a mere rendering of what is visible.

In our zeal to use the arts and humanities in the service of medicine we must never forget their intrinsic worth. It is the enhancement of our experience of life, and the avenue that the arts and humanities offer to aesthetic experience that finally justify them for all humankind, not just physicians.

As with the other dialogues, this one illustrates that a clear converse with medicine has mutual advantages. Medicine provides a rich ground for aesthetic statement. It is a source of images—of suffering, joy, defeat, triumph, nobility, and baseness. All the human emotions are crystallized and fused in the urgency and uniqueness of the human experience of illness.

As with literature and religion, the visual arts are themselves

healing arts. This is their point of most intimate converse with medicine. In structuring these dialogues the Institute on Human Values in Medicine has sought most of all to encourage that synergism between medicine, the arts, and humanities that will enlarge their healing capacities. In a troubled world like ours, where the roots of illness are interwined in complex cultural and social matrices, humankind must draw on every possible source of healing.

Healing must be tailored not only to the illness but to the person who is ill. This means that different modalities will reenforce different healing resources in different persons. We cannot afford to neglect the contributions of art, literature, religion, and philosophy as arts healing for patients, physicians, and society. Perhaps that is as good a definition of "wholistic medicine" as we can provide.

Preface

Within the first few minutes of our initial meeting in December of 1976, one of the members paraphrased Robert Penn Warren on the slow, painful grinding process by which *alone* an idea takes shape in history. In retrospect, this statement was prophetic for the process that unfolded over a year and a half in meetings of the Visual Arts and Medicine Dialogue Group. Of five Institute dialogues between the disciplines,[1] ours,—concerning the relationship between visual arts and medicine—seemed the most uncharted and least explored. Traditional humanities disciplines of philosophy, history, and even literature are more familiar in the growing list of medical schools including humanities studies within their curricula. But at the time we met, only one of us was teaching courses in the visual arts in a medical institution; another, as chairperson of a humanities department within a medical school, was seeking to recruit an art historian to add to the faculty; and a third was attempting to keep his head above water as a practicing artist while completing a strenuous residency in psychiatry.

Except for one or two isolated cases in the country, the visual arts were not yet included among the humanities studied by students in the health professions. And while there was a growing interest in this field by students, humanities professionals, and

medical educators, there was very little direct experience or relevant literature with which to begin our work.

A veteran physician in the group asserted that "medical education tends to produce spiritually and culturally malnourished technicians." Most of us believed as well that professional education in general was guilty of this fault. But while we tried not to

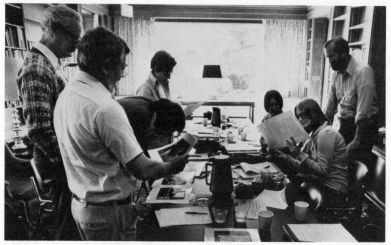

Visual Arts and Medical Dialogue Group

presuppose naïvely that the arts alone could remedy this situation, we did share a common belief that a liaison between art and medicine was not only possible but beneficial.

What we needed from the beginning, and what in many ways were most difficult to pin down, were working definitions of the visual arts and of medicine. In addition, we needed to set these definitions and the interrelationship of art and medicine within a framework of education. Although we considered pedagogy important to our work, we tried not to spend all of our time discussing the endless complexities of medical education or liberal arts education *per se*. Our purpose rather was to decide what we meant by the visual arts and medicine and how each might contribute to the professional education of the other. Even this, in five sessions, turned out to be difficult to accomplish, and we finally emphasized possible influences of art on medicine rather than medicine on art.

Questions of the definitions of the visual arts are addressed in the papers of Geri Berg, John Cody, and Charles Rusch. In the final essay of the volume, E. A. Vastyan makes the point that art has its roots in both *epistēmē* and *praxis.* Art as both an activity and a product has been variously emphasized and theorized about historically. As an object or image, art has served many masters and stood as symbol of countless ideologies. When we talked about the visual arts, we were sometimes referring to the tangible *results* of creative activity, such as paintings, drawings, buildings, cities, sculptures, various crafts, films, and photographs. While some members of the group were never satisfied that we had defined our terms tightly enough, others could work within the loose framework established and even included aspects of the media or dance within our definition of the visual arts. There seemed to be less general need to pin down what we meant by medicine — our collective experience with doctors, hospitals, medical schools, and health care in general seemed to suffice. Although there was less disagreement on a working definition for medicine, there were stronger and more varied opinions on how well medicine was doing its job. But one member of the group, an architect, expressed concern and dispair over the graduates of our art and architecture schools as well. This concern was in part the result of this architect's recent extended visit to several American cities. He speculated, after seeing countless modern high-rise buildings, that contemporary architecture could in some cases be harmful to a person's health in the most literal sense. He wondered if stricter licensing procedures were not necessary to ensure more *human-oriented* buildings and to protect the aesthetic health of the country.

The dialogue group also talked about both art and medicine as *processes.* On this subject we seemed to have found common and often significantly related ground between the two disciplines. Discussions included topics such as visualization theory and brain lateralization concepts, the process and purpose of observation, the nature and function of perception, critical inquiry, empathy, imagination and emotionality, and objective and subjective components of problem solving in both fields.

The articles by Charles Rusch and E. A. Vastyan both address the questions of how we learn. Rusch discusses the need in educa-

tion to examine such root assumptions as "doctors cure patients" and "architects improve the environment." Rusch suggests that these kinds of assumptions are not only misleading but are counterproductive in solving society's problems. Solutions to the problems of professional education, Vastyan maintains, must aim at "understanding the ways knowledge is discovered, learned, valued, and used." Vastyan believes that education in human values, the humanities, and the arts are important ways of achieving these goals in medical education. Berg asserts in her paper that the skills of observation and critical inquiry can be uniquely taught from the perspective of each discipline (art and medicine) for the benefit of the other. But she goes on to say that if art is treated as more than just data or information, it can provide the means for recognizing and clarifying emotional and value-laden responses to people and situations. W. Sherwin Simmons asserts that art can offer medicine its expertise in unique, perceptual experience when it is "crucial that attention not be prematurely focused or immediately related to some preexistent category."

All of the papers in this volume address at some level the possible good that art can bring to medicine or medicine to art. But in "Medical Education: In Transition," Bernice Wenzel questions why we tamper at all with what could be seen as an "unquestionably successful" educational process in medicine. She injects a practical concern for the curricular context in which suggestions for innovation are discussed and states that no medical school curriculum "gives promise of ready revision for the sake of less than absolutely essential material." Vastyan challenges this premise by stating that a "renewed emphasis on education in the arts is especially needed in our contemporary situation." In "Among Other Things, Art," Vastyan argues that art is not merely a luxury, but "an essential component of human culture." He states that humanists above all others have struggled to identify and describe values which "define the human self, enrich the human spirit, and embody human culture" and that they should be made a meaningful part of medical education.

Wenzel then responds to this argument by pointing out that implicit in Vastyan's rationale is the willingness (real rather than affected interest and determination) of the institution in question to incorporate and support such a program.

Another dialogist, John Cody, is not at all sure that art has anything beneficial to offer students during their years of professional medical training. In "The Arts Versus Angus Duer, M.D.," Cody argues that the arts, which "evoke emotionality," can function in such a way as to counteract or undermine the desirable and necessary defenses of the physician in training.

However, in another essay included in this volume, John Cody eloquently describes the deep importance art has had in his own life, both as a medical student and at present. He thus speaks with special sensitivity about "one physician's love affair with a beautiful nineteenth-century symbolic painting." In commenting on Cody's "Grain of Sand," John Burnside notes that the essay is really a case study and states that it is of little concern whether the reader likes William Blake, the artist of the painting under consideration. Rather, the painting becomes a tool to tell of Cody's own credo—the value people have for each other—that we are helped and helpers, that we need respite, that we recognize what we know or at least interpret according to our preparedness, and finally that suffering and evil exist, have always existed, and from them evolve compassion and love.

How does this apply to medical education? Clinical medical education depends very heavily on the case study. It is the case study which forces directed decision making, enhances the retention of information, and is the practicum for clinical medicine. The experience is at once self-revealing and patient-revealing.

Geri Berg, John Burnside, and E. A. Vastyan all discuss art's contribution to medical education in the area of skills acquisition. Vastyan refers to humanistic skills which "sharpen perception, foster perspective, educate sensibilities, develop critical reflectiveness, and liberate the imagination," and sees these as akin to certain clinical skills (awareness, perceptiveness, empathy, discrimination, judgment, tolerance) that lie at the heart of the "art of medicine." In "Visual Arts and Skills Acquisition," John Burnside refers to observation and processing skills which he believes can be sharpened through education in the visual arts. In "The Visual Arts in Health Professional Education: Another Way of Seeing," Geri Berg asserts that in addition to enhancing certain skills, art also teaches us about being human. Art and artists have long sought to explore, document, or in some way understand

what is meaningful in human experience. And in our continuing, mutual effort to re-assert health care as a human value, it is helpful for both physician and humanist to be reminded by artists that to understand human experience for aesthetic or medical purposes is to understand its uniqueness as well as its universality.

In a postscript to his essay, John Burnside relates his personal experience during the working-visit to his clinic of fellow dialogist Eric Avery, himself a physician and artist-photographer. Through Avery's photographs in the clinical setting, Burnside saw firsthand the way in which art can increase awareness of the environment in which one works, extend one's knowledge of the patient, and reveal aspects of the patient-physician interaction that might otherwise remain unnoticed. W. Sherman Simmons, in "The Transformation of the Language of Vision," explains this contribution by stating that "art is rooted in directness and the unique individual nature of the perceptual experience and creative response."

Charles Rusch maintains that certain root assumptions common to both art and medicine must be challenged. Chief among these, he states, is the idea that we need professionals to manage our lives and to find solutions for our problems. In his own field of architecture, Rusch points out that architects do not improve people's lives, rather "people improve their own lives." In his essay "On The Relationship of Architecture and Medicine," Rusch states that the assumption that "doctors cure patients" ultimately impairs peoples' chances for health by leading them away from the potential to participate in their own healing processes.

Eric Avery, as artist and physician, presents a superb photographic essay, "Hands Healing." In his presentation, Avery succeeds with the reader, as he did with members of the dialogue group, in communicating the richness of the meld between art and medicine. He quotes a former professor who said that "one puts one's life in a position to allow art to happen" and maintains that he himself is striving toward a visual art activity which would occur within and be fed by an involvement in medicine.

After viewing these photographs several physicians told Avery that they saw both themselves and their work in quite a different

light. It is as if the photographs allowed these physicians the objective distance necessary to experience the subjective dimension of their work or their art.

At the end of "Hands Healing," Avery comments that he is not essentially a practical man, but "one who like many is searching in these exceptional times for where the creation of beauty and art have gone." He says that he is "simply looking in my experience of medicine for art, because that is what I know. . . . These photographs are really, and finally, just evidence of that search."

We believe that this book is also evidence of that search. In all our discussions we struggled to find the balance between theory and pragmatism. Wenzel sets the stage for this questioning; Vastyan affirms the reciprocal value through an overall humanistic perspective; Cody questions timing and definitions of such a venture. Berg, Simmons, and Burnside suggest ways of implementing any exchange between the two disciplines; and Cody and Avery share with the readers ways in which art has personally touched their lives.

These essays thus represent a collection of ideas regarding the relationship of art and medicine, rather than a univocal approach or position. They raise, but do not always answer, many questions. What are the root assumptions underlying both art and medicine? Can art be seen as a new way of knowing? Can art and medicine both be looked at from the perspective of problem solving? What is a wholistic curriculum, and can we presuppose the validity of this concept? What are the intangible, "irrational" aspects of both disciplines that are so crucial to their functioning?

We believe that, for ourselves at least, we have opened a new perspective on learning in medical education. If we have also interested you in this endeavor, then so much the better. Together perhaps we will hasten that process "by which an idea takes shape in history."

GERI BERG

Acknowledgments

The miracle is that in an era of strictly cost effective, short-term solutions to problems, the Society for Health and Human Values and the Institute on Human Values in Medicine support and believe in the wisdom of dialogue and discussion. Financial support was obtained through National Endowment for the Humanities Grant EH-10973-74-365 and the Southern Illinois University Foundation—Medical Humanities Fund. The dialogues between medicine and the humanities have succeeded on many levels, particularly in affirming the necessity for nourishing the human spirit and mind. This support has made it possible for people to come together to talk: to delineate problems, share ideas, hypothesize solutions. To the countless persons whose vision made the dialogues happen, I am personally grateful.

In addition to the seven other contributors to this volume, the Visual Arts and Medicine Dialogue Group included persons who made significant contributions to our work. I would like to thank Robert Kostka, who insisted in our meetings as he did in his work as a painter, that we pay primary attention to the visual, intuitive, and nontraditional aspects of art. Dr. Mary Stephens, as representative of the Institute Board, enlivened and strengthened our discussions with her own expertise from the perspective of higher education. Dr. Thomas McElhinney, as Director of Programs for

the Institute, provided an overall perspective for the project. For his help as coordinator, planner, facilitator, and friend, Tom deserves my special appreciation. Catherine Nugent, as recorder for the dialogue group, had the difficult task of synthesizing ech of our two-and-one-half-day meetings. Throughout the dialogue, Cathy was a special help and friend to me, and the intelligent, concise minutes she provided for each session enabled us to use previous discussion material more effectively at each successive meeting.

Also, I would like to thank the Southern Illinois University Foundation and Series Editor Dr. Glen W. Davidson for ensuring that all this work would extend beyond the experience of the members of the Visual Arts and Medicine Dialogue Group. Dr. Davidson, and especially editorial assistant Linda Keldermans, were a joy and a pleasure to work with; their editing expertise was essential in the final preparation of this book. Ann Clough and Marilyn Flanigan deserve thanks for their skill in typing the final manuscript.

The Visual Arts and Medical Education, like most work, truly has been a collective effort. I would like to thank my colleagues, Drs. Dennis Carlson, Elizabeth Fee, Sally Gadow, Lorraine Hunt, Archie Golden, and Malcolm Peterson for their personal and institutional support of this effort while I was on the faculty at Johns Hopkins University School of Health Services.

Finally, I have reserved special thanks for my husband, Stuart Oken, who as physician and writer exemplifies the positive human spirit in medicine; and who as father, tried patiently to explain to our two young children what in the world Mommy was doing at the typewriter so much. Thanks again to my friends and colleagues in the Visual Arts and Medicine Dialogue Group and to all of those who helped to bring this book into being.

THE VISUAL ARTS
AND MEDICAL
EDUCATION

Institute on Human Values in Medicine

Board of Directors

Medicine is one of the oldest and most honorable professions in Western society. That its course has been so continuous, albeit fluctuating in prestige, testifies to the ubiquity and urgency of fleshly ills. Regardless of specific titles and rituals, medical traditions have been developed by all societies. These traditions usually have been related not only to the clinical interaction between practitioner and patient but also to the making of the therapist, the process of acquiring the experience necessary to become a healer. Just what constitutes proper training for physicians has been a subject of debate for thousands of years. To learn from practice or from theory; from examples or from texts; to emphasize the healing aspects or the scientific basis—these have been a few of the persistent questions in the long history of medical education.

Contemporary America has become the stage for increasingly intense debates about many aspects of medicine, from selection of students for training to provision of care for the ill. The present volume is concerned with one subject in this array, the visual arts. The purpose of this opening chapter is to describe the context within which the visual arts can become a valuable part of medical education.

1

Medical Education: In Transition?

Bernice Wenzel

If a group of thoughtful observers were asked to characterize modern American medical education in a single phrase, the results would vary widely depending on the perspective and value system of each respondent. However, on at least one point there would have to be universal agreement: the great majority of graduates must achieve at least satisfactory competence in professional skills. Whatever its faults, the educational process unquestionably has been successful in meeting this essential goal. Even the recent increase in the frequency of malpractice suits has seldom been interpreted as indicating lesser competence, but rather as owing to a number of factors, such as greater familiarity with

and acceptance of legal services and fewer personal relationships between physician and patient. Why, then, should serious efforts be made to change an obviously successful process? Why not leave well enough alone rather than risk degrading a system that is functioning effectively?

In his work on curriculum theory and practice, Allan Walldren comments: "A widespread, but overly simplistic, view suggests that the ultimate criterion for measuring curriculum in medical education is the quality of health service provided by its graduates. If health care is less than adequate—and it is always inadequate in some way—it is predictable that someone will propose some curricular change that in his view will correct the purported deficiency."[1] In other words, perhaps medical schools should have more than a single goal. To train competent medical practitioners is the first and overridingly important purpose of such education, to which two more can be added. Like the members of any profession, the graduates of a school of medicine should not only be well developed as practitioners in their field but also as members of society and as individuals. Felix Martí-Ibánez has described his "dream of integrating the unlived lives of the physician—as a universal man, a professional, and a member of society—into a single concept."[2]

In listing criteria for professional values in medical practice, Wayne Menke includes: altruism or the giving of oneself, which "involves a deep commitment of basic importance to the community rather than a narrow and pedestrian specialization"; serving as "representative—and conservator—of the 'values that modern society seeks to preserve'"; specialism and technical competence; and a foundation of generalized learning derived from "a broad knowledge of what has been loosely called the liberal arts."[3]

The medical educator might argue, certainly with reason, that professional training is rigorous enough without confounding it with other themes, no matter how desirable, and that these themes are more properly assigned to undergraduate baccalaureate education. Regardless of this argument's validity, educators now are questioning the extent to which these traditional purposes of liberal arts education can be met because of growing competition with prerequisites for professional schools in the baccalaureate curriculum.

A further consideration is the fact that little direct attempt is made to assess how well such goals are reached in graduates of any level of higher education. It could be claimed that the extent to which a society respects its educated citizens as concerned and knowledgeable contributors is a valid index of the broad success of their education, and that any other measurement is unnecessary and probably impossible. Similarly, each individual has a sense of his or her own personal satisfaction, and estimates from time to time the adequacy of personal resources against frustration, disappointment, and other negative emotions. Absence of any means of systematic evaluation necessitates dependence upon conviction, formed partly by sporadic expressions of appproval or disapproval from scattered segments of society. Current criticism of the entire field of medicine in the United States focuses the blame for many of the perceived faults on the training procedure as the shaping force. Not only are physicians less likely to be seen by the average citizen as wise, cultured, and respected community leaders, but they have also lost some of their status as personal counselors, confidants, and trusted friends. The truth of this criticism is not of immediate concern, but its recognition is mandatory.

Henry Sigerist, physician and eminent medical historian at Johns Hopkins, taught that medicine was principally a social, rather than a biological, science in that its target "is to keep individuals adjusted to their environment as useful members of society, or to readjust them when they have dropped out as a result of illness."[4] On the subject of medical education, he wrote:

Education always presupposes an educational ideal [; thus,] medical education has an ideal physician in mind. Schools and curricula are organized in such a way that their end product will be a physician who conforms with the ideal or comes as close to it as possible.

It is important to know that the medical ideal has changed a great deal in course of time and is evolving constantly. As a result, medical education can never reach definite forms but is obliged to adapt itself to changing conditions. . . . In periods of transition . . . when society and economic conditions change rapidly, when the medical ideal is not clearly recognized, or when different generations have different ideals, there is by necessity unrest in medical education. The majority of educators, conservative by nature, may remain convinced of the excellence of existing

institutions, while others will feel critical and will seek new forms, a system that will train not the physician of yesterday but the physician of tomorrow. At such a moment the time has come for clear analysis of the situation and for courageous experimentation.[5]

Much has been written in many contexts about the impact on today's medical curriculum in the Flexner Report of 1910.[6] The astounding reforms it stimulated and the pronounced superiority of American medicine it facilitated have become symbols for both the attacks and the defenses now clashing in debate. Medicine as practiced by the highly skilled physicians produced by modern schools is said to be medical science, not the art of healing. The patient is considered a laboratory object rather than a human being. The medical schools have become a major part of a powerful, unresponsive establishment. The medical curriculum is dehumanizing. Simplistic accusations these, expressing yearning, frustration, alarm, and truth in varying proportions.

Like so many aspects of our present society, medicine as practice and as science now simultaneously seems to offer salvation and damnation, the one for those able to use the system, the other for those who cannot. Such an intense dichotomy is the classical germ for a love-hate relationship as strong as the conflict presented. We are struggling to solve many such conflicts, but the poignancy of that surrounding medicine is especially great because it speaks to life and death. "A physician and a patient taken together make up a social system. They do so because they are two and because they have relations of mutual dependence."[7]

Patients, or would-be patients, who feel deprived of any aspect of the fundamental human relationship implied in the concept of medical care may object strenuously to their perceived loss. The practitioner who must deal with the unceasing practicalities involved in making the best possible medical decisions for growing numbers of patients also faces a draining conflict. The dilemma of time can often be solved in only one way—by sacrificing the inevitably time-consuming interactions of friendship with one patient in order to meet the medical needs of an additional patient who could not otherwise be treated. That the physician sees such limitations as a sacrifice, not as a preference, is important to understand. When a choice must be made, the decision is clear—the best possible ther-

apy must be provided for the largest number of patients. In the same way, most patients with serious physical disorders seek first the best care available for their specific problems rather than the most popular bedside manner. That such care be skillful, accurate, compassionate, and universally available is the unquestioned wish of all parties in the therapeutic relationship.

Whether the medical school can contribute by weaving certain aspects of the visual arts into its curricular fabric is a new issue. Today's ideal physician, to use Sigerist's term, is far more likely to be characterized as a scientist than as an artist. According to Martí-Ibánez, this has not always been the case:

If we had to decide what figures incarnated the greatest medical knowledge available at each period in the history of medicine, we should choose the seer for Mesopotamia, the priest and the philosopher for ancient Greece, the physician-soldier for ancient Rome, the erudite monk and the alchemist for the Arabian and European Middle Ages, and for the Italian Renaissance—the artist and the humanist. Each one of these figures was the leader who provided new impetus for the medicine of his period. . . .

The renaissance of medicine developed parallel with the *re*birth of the arts and literature. The new ideal of human and political individuality brought in its wake the study of the forms and functions of man. Illness ceased to be a divine punishment and became a derangement in the harmony of nature.[8]

Little historical precedent exists for a proposal to teach visual arts in medical school. Even in his famous "Bed-side Library for Medical Students," William Osler included no collection or treatise on graphic art.[9] No record could be found of either formal or informal instruction in visual arts as conventional in the medical education of any era, despite the persistence of pleas for broadly-educated physicians from all segments of the American medical community throughout the last century.[10] The opportunity to take regularly-scheduled courses *outside* the medical school for elective credits toward the M.D. degree has been offered recently at some schools, usually with scanty enrollment in the arts.[11] Visual materials have been widely used for illustrative purposes, but courses developed around the central theme of visual arts have

been virtually nonexistent until a few current examples were created (some of which are discussed in following chapters). To the extent that such subject matter has been considered at all, or thought desirable for the fully-trained physician, it was expected to have been presented earlier in the educational process. A frequently recurring theme in requirements for admission to medical training since the beginning of this century has been that of prior instruction in what would now be called the liberal arts. This expectation continues to prevail for medicine as for other professions, although the amount and difficulty of basic scientific courses underlying the medical curriculum make it less likely that the premedical student will find the time or the inclination to partake widely of alternative courses.

Failing adequate educational experience outside science before entering medical school, and given the well-reasoned and substantiated principles on which present medical instruction is based, should the medical student be exposed to liberal arts instruction during professional training? If so, how can it be done? To anyone unfamiliar with the formal details of modern medical education, the rigorous and unrelenting schedule characteristic of most institutions differs so strikingly from almost all other curricula in higher education that it can hardly be grasped at first. To anyone familiar with the personal styles of most faculty members in higher education, the unremitting intensity with which the medical curriculum's components are assailed and protected by its teachers presents no surprises. The combination of a concentrated schedule and strong territoriality is a major challenge to the introduction of significant changes on almost any scale.

Although there is considerable variation among schools, it is still true that during the largest part of a four-year program leading to the M.D. degree, the student is actively engaged in relatively formal learning situations and has very little unstructured time. In the most typical pattern, the first two years of a four-year curriculum are spent mainly in classroom and laboratory instruction in basic science courses and others more transitional between basic and clinical concepts. Sometime in the second year, usually near the end, the transition is completed and the student's time is spent mainly in clinical situations. Working with patients, attending rounds, being on call, writing reports, studying the litera-

ture—all these activities are not only exciting and rewarding but totally time-consuming as well. Throughout the last two years, most schools now provide time for elective courses, all of them entirely or primarily clinical in nature. In the two principal variants of this four-year plan, instructional time is similarly at a premium. The three-year curriculum condenses the four years into three, partly by elimination and partly by full scheduling in summers. The five- or six-year curriculum enrolls the student at an earlier point in the course of higher education, but does not reduce the concentration of formal instruction.

None of these patterns gives promise of ready revision for the sake of less than absolutely essential material. The case for inclusion of any topic must be made so convincingly that it will be accepted as essential. Since the components of the present curriculum are chosen almost entirely on the basis of their relation to patient care (and even here, there is by no means universal agreement), there is no ready mechanism for demonstrating how critical an additional topic might actually be. The question here is whether the visual arts can provide a vital contribution to the making of tomorrow's physicians, and thus be deemed essential for their education. More extensive consideration will be needed to answer the question.

If that answer is positive, then differing designs will be created for providing the experience, and schools will soon begin comparing their programs. If a workable format can be found for scheduling, the greatest problem is likely to be with teaching. As with any other academic group, artists speak best to each other. How to create a "bioart"—a credible, irresistible meld that will permeate the lives of their medical students—is a serious challenge. Poorly executed, the results could be trivial. That wise commentator, James Thurber, once observed that "whereas a little elm tree is bound to grow up to be a giant elm tree, a . . . writer who at , twenty-two is commonplace and mediocre is bound to grow to be a giant of commonplaceness and mediocrity."[12] Even a sound idea can grow into a nightmare; not only courageous but also superb experimentation will be essential to guarantee this idea its hour.

2

Hands Healing: A Photographic Essay

Eric Avery

The photographs included here represent my most recent attempt, working as an artist-physician, to make images of the interface between art and medicine. They were taken in October, 1977 at the invitation of the Department of Humanities, Pennsylvania State University College of Medicine, Hershey, in preparation for the last Visual Arts and Medicine Dialogue Group meeting. Although I believe that images exist in a world of images and words in a world of words, and recognize some of the limitations of trying to use words to talk about pictures, these photographs did develop within the context of our dialogue on the relationship between art and medicine. I feel, therefore, that it is appropriate

to attempt to describe some of my thinking and the events which are layered around these particular images.

I must add, though, that this introduction is independent of the primary experience of looking at and being with these images. It is separate from and cannot add anything directly to them. If these images are able to allow one to experience art, then they are not specifically about anything. Art is, for me, experience in relationship to special images, which simply exist in the world. This relationship of a dependent, nonanalytical experience of art does not seem too unlike the experience of being with a patient beyond the analysis of his physiochemical, physiological, and psychological phenomena. This experiential dimension in both art and medicine is the same. Although such a statement might seem obvious, in my short experience in both these disciplines I have come to understand and develop it very slowly. When I left my art training eight years ago to begin medical school, I was stubbornly committed to the idea of developing simultaneously as both a visual artist and a medical doctor. I have always believed that at some point my interests in what then seemed to be totally disparate disciplines would be welded into a visual-art activity that would occur within and be fed by my involvement in medicine.

The experience of making these photographs has led me to the conclusion that art and medicine might be inseparable. As I look back to the time before I created these images, I see that there has been a sequential development in my thinking about art and medicine. As I was making the transition from art into medicine in undergraduate school, I was studying with an exceptional teacher-printmaker, Andrew Rush, who stressed that one puts his life in a position to allow art to happen. Images are not the point of the activity but are instead debris, of a very special kind, left behind as artists, in the process of making art, become themselves. Very slowly this positioning has been taking place for me in medicine.

Rush also stressed the importance of seeing art, recognizing it when it is happening. So I am in medical school, using my eyes all of the time, and find myself developing that special kind of skilled seeing that is in medicine and relates to art. But where is the art in the seeing parts of medicine—patients in physical diagnosis, microscopic tissue slides in pathology, subtle changes in radiodensity in X rays, or computerized visual representations of sections of

the body in the CAT scanner? Even reflected sound in diagnostic ultrasonography and the electrical activity of the heart and brain are transformed into visual images, each of which requires the most subtle and skilled kind of seeing.

But no one, except possibly the most radical of conceptual artists, would consider these images from medicine, or the seeing of them, as art. These images are related to art, but differ because in each something specific is being displayed. Each can be read at the level of content only. They illustrate but do not illuminate; the degree of interpretation is minimal.[13] What else needs to be present in images from medicine which will move them into the realm of art? Quite simply this missing element seems to be the specific workings of artists upon their subjects.

Max Raphael defines art very much as my teacher did, but adds one additional component: "Art is an equation, an interplay of three factors—the artist, the world and *the means of figuration*." This last element in the equation of art, figuration, is what I am talking about. Raphael explains figuration in this way:

Intensity of figuration is not display of the artist's strength; not vitality, which animates the outer world with the personal energies of the creative artist; not logical or emotional consistency, with which a limited problem is thought through to its ultimate consequences. What it does denote is the degree to which the very essence of art has been realized; the undoing of the world of things, the construction of the world of values, and hence the constitution of a new world. The originality of this constitution provides us with a general criterion by which we can measure intensity of figuration. Originality of constitution is not the urge to be different from others, to produce something entirely new, it is (in the etymological sense) the grasping of the origin, the roots of ourselves and things.[14]

But simply knowing about figuration is not the same as being able to realize it in images. I've been thinking about this problem of art and medicine since entering medical school, and as I look at it now, I think that it was with stubborn persistence that I persuaded my training hospital during my third year of psychiatry residency to allow me the time and space to try to demonstrate a hypothesis which would express one connection between these two seemingly disparate disciplines. This hypothesis was that *one*

relationship between art and medicine is space. I felt that this purposely ambiguous and seemingly nonsensical statement about the relationship between art and medicine would clear the air for me of many of the basic assumptions I held about both art and medicine, such as art is about beauty and medicine is about science. Then with a somewhat clean slate, I used my own version of the scientific method to generate a visual activity to investigate the concept of space in my hypothesis.

As I began this work in December of 1976, I was invited to be a participant in the Visual Arts and Medicine Dialogue Group, which was supportive and also helpful in clarifying aspects of my experience in art and medicine. Also, at the same time, I began to work with two extraordinary members of the Division of Geriatric Research at my hospital, Dr. Barry Gurland and Dr. Joseph Zubin. Working with these two men, I divided the concept of space in my hypotheses into two categories—public space and private space. Then I structured a photographic activity to examine both spaces as they related to the elderly in New York City. These divisions of space and the structuring of an investigative photographic activity are intimately connected with not only how the photographs shown here were made, but also how they were edited.

As this photographic work with the elderly in New York City was underway, I was attending the Visual Arts and Medicine Dialogue meetings. As we were preparing for our last meeting and discussing plans for this book, I was invited by E. A. Vastyan and John Burnside to spend three days doing photographic work in Hershey. Their Department of Humanities had been recently awarded a federal grant from the Department of Health, Education, and Welfare to investigate "humanistic skills in the clinical setting," and my photographs were to relate to this topic. The invitation was generously open-ended, and I was left to define a problem and to plan a visual-art activity around it. Initially, I had planned to spend three days photographing the activities of an attending physician at work, a resident at work, and a medical student at work, thinking that some significant differences in the way they worked would become apparent in the photographs.

While photographing Dr. Burnside the first day, I realized that he was an exceptional clinician and that one aspect of his clinical

style, specifically how he used his hands as he taught, examined, and communicated with his patients, would prove useful if recorded visually, recognized, and taught as a clinical humanistic skill. I thus determined to photograph the three clinicians from this point of view.

The photographs shown here were made on my second day in Hershey, while photographing a plastic surgery resident, Dr. Jane Petro. On the morning we began working together, as she was explaining that she was expecting an unusually quiet day, she was called to the emergency room to evaluate a twenty-three-year-old Puerto Rican man, who, while chopping wood with a hand axe, had completely severed part of his right hand from his body, cutting across the palm, just at the metatarsal joints. These photographs, selected from a larger set of forty-five black-and-white images, were taken over the next ten hours, with the patient's consent, as members of the Department of Plastic Surgery worked to re-implant his severed hand.

These then are photographs of hands healing another hand. The photographs do not illustrate the technical aspects of the surgical procedure, but instead illuminate some aspects of the experience of doing surgery. They are organized so as to take you through the public space of the operating room and into the much more private surgical space —the space of healing.

Since taking these photographs in October of 1977, I have shown them, either as the set alone or in combination with a sixty-slide set of color images that I made at the same time with another camera, to various sized groups of professionals, nonprofessionals, and medical students. If considered only from the point of view of how images might be used in medicine and medical education, the various reactions to these photographs have been surprising and illuminating.

One remarkable occurrence during the showing of these photographs was how quickly and consistently it lead into a discussion of the values and belief systems of the viewers—not merely how art or photography works, but how the viewers saw themselves in relation to medicine and surgery, to their bodies, and to their own medical experiences.

It is interesting but not surprising that the individuals who had

the hardest time "seeing" the images were those most familiar with what was being shown, the surgeons, who in their training and experience had detached themselves from some of what was shown in the photographs. Being familiar with the language of the procedure, they tended to move through the images, as if looking through a weekly news magazine, pausing only to ask procedural questions about technical aspects not clearly shown.

When it became obvious that these images were not intended to illustrate technique or to teach anything specific, the surgeons' questions dropped away. In discussions following the showing of the photographs, surgeons were quick to talk about aspects of the procedure that nonprofessionals questioned, such as how and why the patient was in surgery. Some surgeons also commented on how the patient was systematically removed from awareness in the operating field by the body draping and ritualized preparations. While some responses by this group included comments about the quality of the photographs, others noted that it was, indeed, "an interesting way to see an operation." One senior surgeon expressed surprise at the degree of physical intimacy (in terms of physical proximity) present.

The most interesting and illuminating responses to this work came from the plastic surgery resident I was photographing. After viewing these images, she spontaneously began to cry, expressing the feeling that she had been unaware that she "was doing anything so beautiful." She explained that the experience of being photographed in surgery had a profound effect upon her, that she had been becoming a surgeon for the last five years of her residency and on the day I photographed her, she felt she became a surgeon. Several weeks after she had seen the photographs, she informed me that, to my surprise, she was having difficulty in the operating room detaching herself from elements she had seen in the photographs. I was concerned that possibly my photographs should not be seen by the person being photographed, that I was in some way tampering with the necessary distance surgeons need to do their work. However, to my relief, she reported that over the next two weeks, she had moved through this reaction and felt her experience in surgery had only been enriched by what had happened with the photographs. She explained that now when she is in the operating room, she can

consciously focus or shift her attention to various aspects of the surgery. She can attend to what I have seen and shown her about surgery, or she can remain detached from it.

In a related way, I experienced some level of transformation with this group of images, not only as an artist but also as a clinician. As a medical student I had been in the operating room many times, not as a viewer of the phenomenon itself, but as an active participant, holding retractors or learning anatomy or surgical technique. But on the day I made these photographs I was simply an artist looking at his subject, as if I were standing at the very edge of my experience in medicine, and really, for the first time, looking at the act of surgery itself. The photographs seemed not to be distancing me from the procedure, but moving me closer, as if I were peeling layers off the experience, like removing layer after layer of an onion, while I watched this miraculous transformation taking place. Even now, months later, this sense of having witnessed something very mysterious and personal stays with me.

In general, the public's response to these images has been more open and spontaneous, with remarkably few disturbed by the subject matter and unable to look at the photographs. Most respond initially with some anxiety, but as they begin to view the images, they are quickly intrigued by what they see and ask standard questions about the procedure. Usually at the point when the hand is shown back on the body, questions stop and there is a rich, palpable kind of quiet in the room. After the presentation, viewers discuss their reactions to the photographs. A similar discussion occurred when the photographs were first shown at a meeting of the dialogue group. As I watched one member of the group viewing the photographs, he initially seemed interested and asked many questions about the procedure. Then the questions stopped, and he seemed bored, detached, and impatient with the presentation. But about two-thirds of the way through, he again seemed interested and involved in the process.

He later explained to me that initially he was involved with the images at the level of technique, at the level of information. Then as he began to feel that the questions were separating him from the direct experience of looking, he stopped asking questions and quickly realized that he was uncomfortable and painfully bored

with my presentation, feeling as though his body wanted to pull away from the photographs, yet, at the same time, feeling that he was being pulled visually into the images by the beauty of the presentation. This tension, the result of being simultaneously pulled in two directions, represented the simultaneous engagement of two conflicting perceptual-response systems. This tension not only forced him to see the images more clearly, but also to experience something beyond the images: his sense of his body's completeness, his own response system to pain should he have lost his hand, and in some way, aspects of his value system as he judged his own experience. He asked himself if these photographs had anything to do with art and whether the experience he was having was positive or negative. This kind of seeing, when images resonate beyond their content, is how art becomes effective. Here the art is contained in images from medicine. This is not art and medicine now, but is instead art in medicine.

For me, these photographs exist and work in the space between art and medicine. They emerge out of my experience in both of these disciplines and yet are not entirely of either. When the photograph brings into a stabilized condition an image that is an extension of myself, then "art" happens; when the surgeon takes a piece of the body which has been severed and reattaches it in its original position, then "healing" begins.

There remains something mysterious and magical about these transformations that is beyond what I know about photography and art and beyond what I know about surgical technique and tissue repair. When these two conditions of technique, magic and passion, are present, along with the skills and knowledge required, then a transformation takes place that we call art in one case and medicine or healing in the other.

As you can tell by now, I am not a practical man, but rather one who is searching in these exceptional times for where the possibilities for the creation of beauty and art have gone. Clearly to me they are in the world, in some disguised form, waiting to be discovered and, in the process of being discovered, re-created. I am simply looking in my experience of medicine for art, because that is what I know, and about all I can do. These photographs are really, and finally, just evidence of that search.

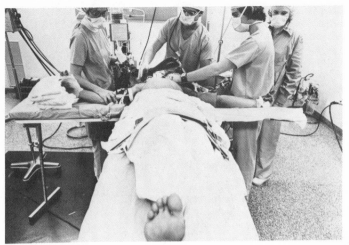

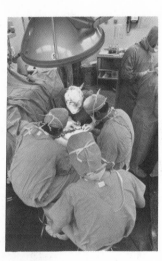

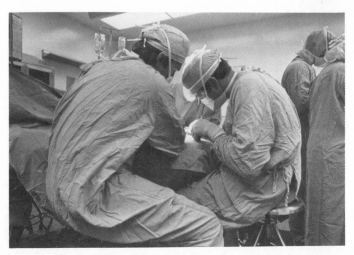

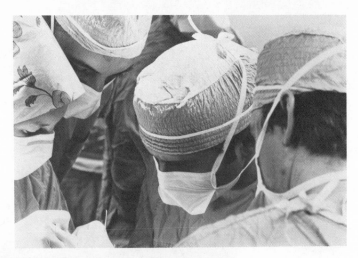

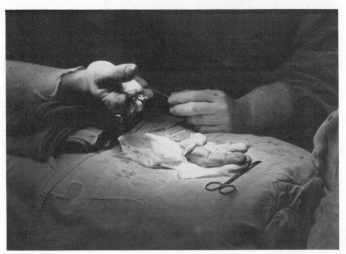

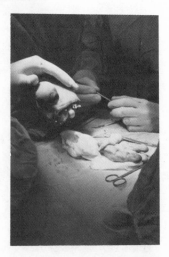

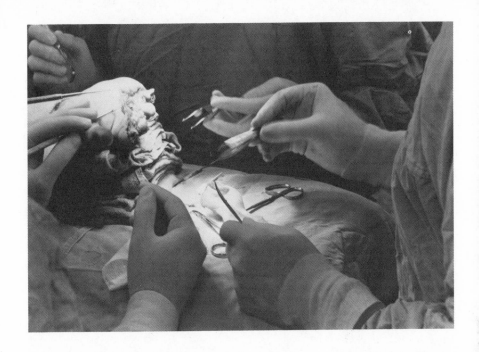

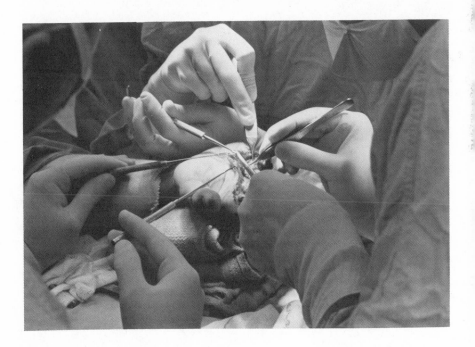

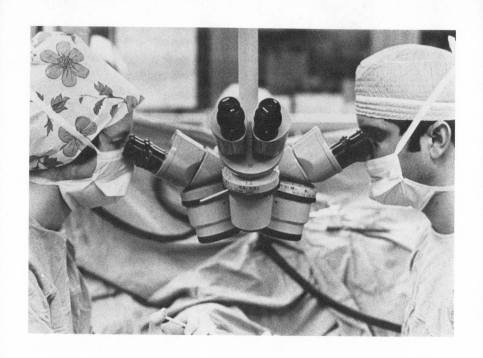

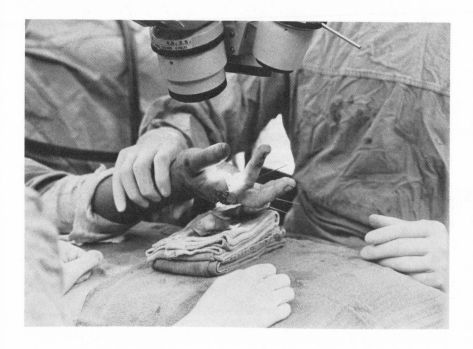

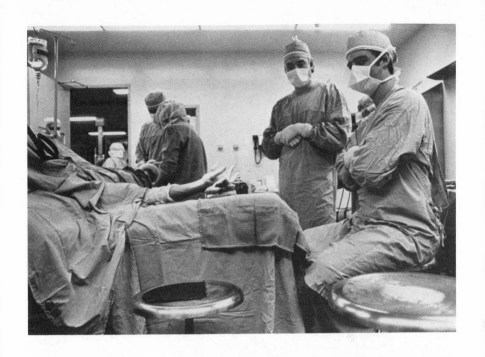

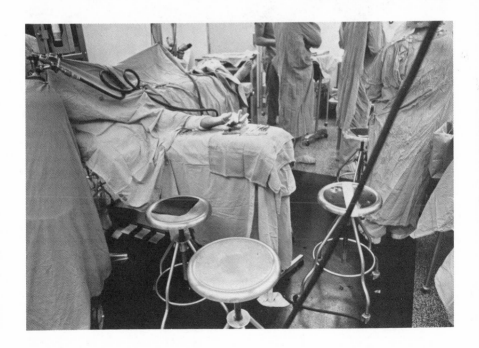

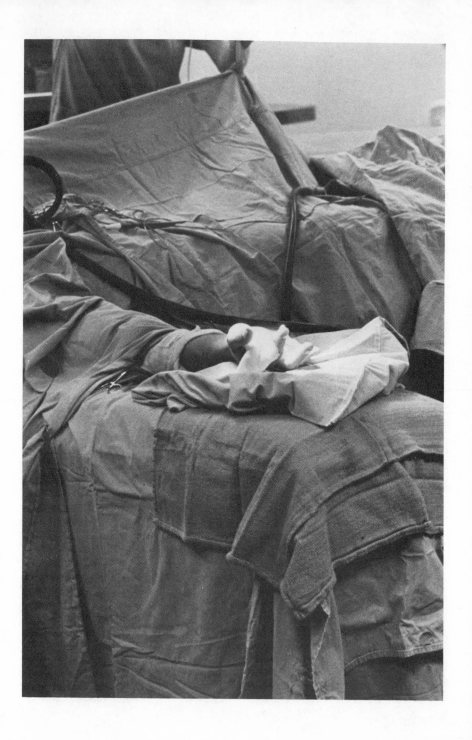

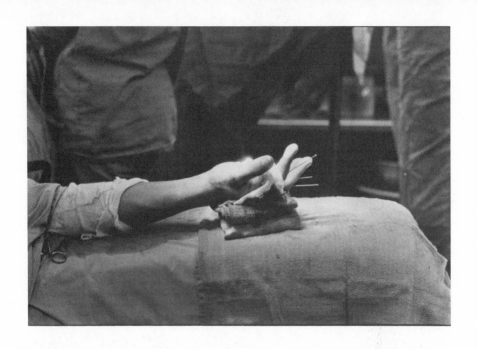

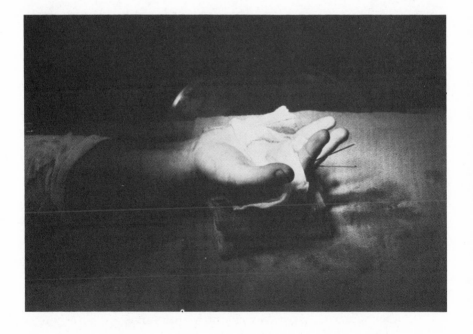

The medical school experience is often anxiety-producing for typical students, who may take what happens to them in confrontations with illness and death as an assault on their own integrity and sensibilities. As a result, students often use certain psychological defenses to safeguard themselves from becoming overwhelmed with feeling to such a degree as to impair their efficiency. The effect of art, by contrast, is to evoke emotionality. Art functions in such a way as to counteract or undermine these at times desirable and necessary defenses. In this paper I discuss the value of safeguards against emotional flooding concentrating on the role of art in keeping these safeguards from becoming too extreme and fixed.

3

The Arts Versus Angus Duer, M.D.

John Cody

Humanistic and aesthetic studies may be woven into the fabric of the physician's education with results that are paradoxical and disappointing if certain considerations are overlooked. For one thing, the humanities do not invariably generate the farsighted and generous view of mankind that we expect of them. Furthermore, the possibility must be faced that some physicians actually may function better when they withhold or stifle their pity, compassion, and esthetic responses than when they allow them full sway. And finally, there is the troublesome fact that educational, or rather scholastic experiences in the narrow sense, are never the most critical determinants of what kind of adult one will become.

In this essay,[15] I shall tackle each of these points in turn. And, in conclusion, I hope to explain how, in spite of these considerations, an enduring love for the arts and humanities can maximize the benefits and minimize the pitfalls of that unique emotional style imposed on physicians by the nature of their profession.

It seems almost axiomatic to state that the arts uplift and the humanities humanize. Yet, compassion and concern for the good of mankind do not necessarily accompany even high achievement in these fields. Immense artists, even of the stature of da Vinci and Goethe, sometimes are detached, aloof, and look down on the rest of the human race. Philosophers—Schopenhauer and Rousseau, for instance—may be fully as scornful and misanthropic. Composers, not uncommonly have been angry, domineering, or possessive men—witness the great Beethoven, Wagner, and Richard Strauss. And so on, for all the other avenues of art and letters. There is nothing in the practice of poetry, for example, that immunizes poets against conceit or perversity, and other kinds of authors are as frequently suspicious and reclusive. Historians and classical scholars also, despite thorough humanistic learning, may live in an artificial environment and fail as human beings, becoming dry and pedantic prisoners of their ivory towers. We must be careful therefore not to exaggerate the public spiritedness of men of unique sensibility and attainment; they may be gorgeous hothouse plants.

Compassion for and comprehension of one's fellow is therefore not synonymous with humanistic and aesthetic training and proficiency, nor obviously are the two even necessarily linked. Rather, compassion, in the widest sense, is *applied* humanities, *applied* art-sensibility. An all-embracing concern, a capacity to care about the destiny of others, individually and collectively and everywhere, is close to the heart of the liberal ideal. Undoubtedly, ample and wide-ranging cultural experience, as an integral part of one's early molding, is a precondition for evolving a humanistic philosophy of maximum breadth and depth—and I will say more about this later. But even the best liberal education, rich in the arts and humanities, is not in itself sufficient for the flourishing of such a philosophy. There are inhibiting forces so overwhelming as to freeze the flower in the bud regardless of how carefully the soil has been prepared. It is important to become aware of these blights, in particular one

having to do with the foreclosure of feeling that is especially power-ful and prevalent in the experience of medical students. In what follows, I will try to show how and why this inhibition makes its appearance, why it is not a feature of medical education alone, why it may be temporarily helpful and even necessary, how it tends to outlive its usefulness, and what can be done to curtail its injurious longevity. Finally, I will suggest why immersion in the fine arts and humanities may be helpful in bringing about the freeing up and revival of emotion and sensibility.

An early portrait of the physician as smooth, impersonal, and all-business is Angus Duer, M.D., an antipathetic character in Sin-clair Lewis's novel *Arrowsmith*, who fascinates and repels us by his unflappable poise and mechanical efficiency devoid of all human warmth. Duer is almost a stereotype of the kind of doctor, every-where deplored, who regards his patients solely as embodiments of this or that more or less interesting disease and as sources of income. It is widely, and I think mistakenly, assumed that *the* cause of this technical, manipulative, and asocial approach to pa-tients, dealing with them as objects rather than as persons, is to be found in a professional preparation marked by overconcentration on science and neglect of the arts and humanities. It is easy to see the evolution of such an assumption.

That unfortunately small and favored percentage who truly love the arts know for a certainty how much this love has enriched their own lives. They will assert that art has refined and improved them in some way, made them more alive, sensitive, aware, reflec-tive, idealistic, compassionate, and generous—in a phrase, more completely and fully human. With art taking them by the hand they have been led, they believe, to a broader and deeper matu-rity than would have been reachable without such guidance. Cor-rectly perceiving themselves as the fortunate few, they are pain-fully aware how exceptional is their development, what little role contact with art plays in the lives of so many others. This is a great pity, they feel, for to them the emotionally and intellectually refin-ing evolution that comes through art-experience is wholly and absolutely desirable. All people, whatever their lot in life, what-ever their job or profession, would perforce be better off, they think, for having undergone a similar evolution. A humanistically cultivated plumber, for instance, would necessarily be—other

things being equal—a better plumber than one lacking that prep-aration. The reason seems inescapable: the former would be an improved, more developed human being than the latter and, therefore, better equipped to contribute to society's well-being. That plumber would work in such a way that customers, over and beyond any satisfaction they gain from their repaired fixtures, would have the additional lift that comes from encountering a person who is warm, whole, and many-sided.

Then, if one multiplies this encounter by all similar ones in the general run of things, involving clerks, bus drivers, telephone operators, teachers, policemen, and so forth, the end product should necessarily be less abrasive and cold, more agreeable and civilized community life than presently is our lot. Everyone, from this point of view ought to be urged and helped to become a sensitive, responsive, feeling person. And since art-experience ap-pears so powerfully to incline one in this direction, it seems inevi-tably to follow that such experience should be included univer-sally at the core of all training and education.

The assumption that contact with arts and letters renders one broader and more humane as a matter of course must, however, be examined with a little skepticism. Though it seems reasonable to suppose that education along these lines, with its celebration of the complexity, diversity, and resources of human nature, might enable the developing doctor to become more insightful, inter-ested in, and ready to serve his patients, is this necessarily really so? In other words, does cultivation in these areas invariably rub off on one's behavior? I have already suggested that painters, musicians, poets, and writers are not invariably public spirited and large of heart, no more so perhaps than cab drivers and brick-layers. Sometimes the naïve and unsophisticated are the most gen-erous of all. Can anyone deny that religious persons, even those who have confined their reading to just one book, are quite as likely to be kind, concerned, and selfless as are highly trained humanist scholars?

Moreover, not all educators accept the proposition that the bud-ding practitioners of every discipline, and especially medical stu-dents, have only to gain and nothing to lose by being broadly educated and turned into cultured, aesthetically sensitized adults, though the notion is so intrinsically attractive that, like the prom-

ise of heaven, it seems almost perverse to doubt it. Nevertheless, before meddling with the present system of medical education—which, after all, has served us pretty well—we should face the possibility that enhanced emotional responsiveness including that induced by deeper cultivation in the humanities may *not* be what all medical students need, and furthermore that it may in fact be a detriment to the effectiveness of at least some physicians.

To repeat: the arts and artists are not perpetually and emotionally involved with humanity. They are often as coolly objective and impersonal toward their human subjects as that focal point of universal opprobrium—the cerebral and detached medical specialist. Nothing demonstrates this dehumanized and analytic side of art practice any better than the example of what takes place in the ubiquitous "life class." Here a naked human being stands before a crowd of art students who convey her outlines, planes, and proportions to paper and canvas. For these aspiring artists, the model is primarily a thing, an object. They may regard her as a beautiful thing, or as a visually interesting thing, or as a source of shapes and colors that can be rearranged effectively in an infinity of ways. But the students never talk with her while they are drawing and painting. Even during breaks, they are apt to converse with each other and with the instructor while she rests somewhere, usually alone. The character, personal experience, and feelings of the model are irrelevant to what they are all there to accomplish. Of course, what these students are doing is practicing, not producing artworks. Nevertheless, there is much in the attitude and procedure of the professional painter and sculptor that is akin to the detachment and indifference toward the model displayed by these students. Certain great artists, though not by any means all, have managed to elevate the *what* of their masterpieces—that is, their subject matter—to the same level of importance as the *how*. But for many *how* a thing is painted or carved is the be-all and end-all. Nor can it be denied that, no matter how intrinsically interesting the original subject, if its embodiment in paint or marble does no more than faithfully convey its likeness, then the result is counted as having fallen far short of the ultimate reach of art. The model is and remains only the point of departure for the artwork. The importance, significance, and emotional power of the artwork inhere mostly in itself and are not primarily

the contribution of the model. Artists, for the most part, do not even *talk* to each other about their models. They talk about art— its theories, trends, manifestations, techniques, materials, practitioners, and so forth—and there is little that is "humanistic" in all this; it is merely shoptalk. And what is true of the graphic artist is true of other creative people also, and to a greater or lesser extent of the scholar in the humanities as well. It is instructive to compare their habits with that of the physician. How do such scholars talk about their own fields? They talk about their theories, trends, manifestations, techniques, materials, and practitioners—exactly as artists and doctors do. In the light of this observation, what reason is there to assume that art-experience will do more for physicians than for artists? A universal tendency in all fields is to narrow one's view to what is most easily manageable and eliminate what is too complex or unruly.

Those who advocate an infusion of the humanities into medical education generally act, therefore, according to two seemingly self-evident hypotheses. The first is that a humanistic education is good for everyone, including medical students; the second is that an individual imbued with the spirit of the humanities is more likely to be humane, compassionate, altruistic, and community minded than one not so imbued. But the truth seems to be less neat than this assumption. It may be, for example, that to strengthen the humanistic element in the education of physicians may mean promoting something irrelevant or even detrimental to good medical practice.

How to decide between these possibilities? It would certainly be reassuring if there existed rigorous laboratory support for the claim that art-awareness and humanistic sensitization produced better doctors. But I have been unable to discover much along these lines, and I find myself forced to draw on my *own* art-experience, bolstered and interpreted in the light of my psychiatric training and practice.

If I may be excused then for introducing an autobiographical note, I will present some observations I made in the dissecting laboratories of two medical schools. It is often pointed out, usually wryly and ruefully, that a physician's first patient is a mummified corpse, and that this shocking initiation sets the tone—considered an unfortunate one—for all subsequent relations with patients. In

a sense this is true, but I am not sure that it is altogether something to be regretted. Even before the dawn of scientific medicine medical educators traditionally decreed that the freshman doctor's first professional experience should be this brutal confrontation with death. There are of course obvious and conscious reasons for beginning with the study of gross anatomy. However, it may be that these educators were also drawing on some deeper, intuitive wisdom in advocating this approach. My own observations tend to bear this out.

For a physician my background is peculiarly checkered. I enrolled in medical school, not once, but twice,—the first time as an artist; the second, as a conventional medical student. My first acceptance followed heavy emphasis on art and the humanities in high school and college, plus drawing and painting lessons on the side at an art school. At first I planned to become a fine artist but later decided with more modesty to become a biological and medical illustrator. My first class at Johns Hopkins was, of course, gross anatomy, and for a number of months I dissected a human cadaver side-by-side with five artists also in training as scientific illustrators. Then, after five years or so of earning my living at this craft, painting flora and fauna in the Trinidad jungles, and making surgical drawings in the operating rooms of the Lovelace Clinic and at the University of Arkansas Medical Center, I decided to become a physician. I enrolled as a student at the medical school in Little Rock, where I again studied gross anatomy and where this time my tablemates in the dissecting room were doctors in training whose interest in and exposure to the arts and humanities was not extensive.

The two groups—the artists and the medical students—were temperamentally very different from each other, as was their approach to the subject material and to the dead body itself. These differences in style made a strong impression on me, as did my observation that underlying them was a pervasive dynamic shared by both groups.

For those who themselves have not had the experience, a brief description of the neophyte's first contact with the anatomy laboratory might be enlightening. Until they were needed, the cadavers at one school were stored naked in a chilled room; in the other they were deeply submerged in preservative fluid in a tank

resembling a swimming pool. In the storeroom, bodies hung from every wall by means of ice tongs inserted in their ears. The scene thus presented was as macabre as the catacombs at Palermo, and I will never forget the dismal impression it made on me. Nor will I forget either the first glimpse I had of those other cadavers when an attendant, using a long pole with a hooked end, caused them to rise and break through the surface of the murky fluid like divers coming up for air. Before he was finally able to secure a body and drag it out of the tank, he had momentarily entangled several others, only to have them slip off the pole and slowly sink out of sight again. Conversation throughout this selection process was dryly matter-of-fact. Students and attendant alike behaved as though we were purchasing sacks of peat moss at the garden center, and an occasional witticism, made *sotto voce,* was more or less expected by the authorities and scarcely frowned upon.

The bodies were placed on their backs on narrow tables equipped with tin lids, which were put over them at the end of the day to keep them moist and flexible. No one in either of my two groups was at all eager to touch the body. Dark and wrinkled, it had a pungent, not too offensive odor, and an oily and leathery surface. When we finally managed to touch it, the body felt inhumanly cool. At first, we wore gloves and dissected daintily, trying not to let ourselves come into contact with it. Out of ingrained habits of politeness we also kept our forearms elevated, shrinking from imposing our weight on the still figure. One of the students, on inadvertently bumping the cadaver's head, involuntarily murmured, "Oh, excuse me." But our most astonishing discovery perhaps was that the corpse drew heat from our living bodies and as a consequence melted. Its fat deposits at room temperature were, of course, solid. But as we worked over the body its fat turned to oil and ran in rivulets down its sides and soaked the sleeves of our lab coats and made them rancid.

There is no need to go into further grim details. The important point is that in the beginning, the body was still very much a person to us, though a strange, forbidding, desecrated person. We were inclined to treat it as such and felt a strong inner revulsion against doing anything to it that would not have seemed proper had it been alive. When we first sliced into the chest, and the oil began to run, there was a suppressed sense of some atroc-

ity having been committed. Yet, before many hours or days had gone by these reactions faded. We had discarded the gloves and were leaning on the body as though it were a block of wood. Once someone even placed a paper sack of caramels on the belly from which we all calmly helped ourselves from time to time. In the minds of both groups, the dead human being had undergone a transformation and dwindled away to a mere *cadaver*, a dehumanizing and comforting word that henceforth divested it of anything in common with ourselves.

Differences between the two groups emerged. The medical students appeared not to *see* the cadaver. It existed for them as something to go to work on—a *terra incognita* to be mapped out or, to change the metaphor, a latent message which it was their task to decode. They busied themselves at once in assigning names to everything and in clarifying for themselves the functional relationships of one part with another, asking themselves, for example, to what bone did such and such muscle attach or from what branch of the aorta did this or that artery spring. As quickly as possible they seemed to translate the body into a cognitive schema, a mental blueprint detailing the way the body was put together.

It is perhaps only to be expected that the artists took another and predominately concrete and visual approach. When they looked at the anatomic structures, their gaze seemed to bounce off the surface, to come into contact with it and rebound from it physically. They actually *saw* the body, and just that particular body. The others, by contrast, tended at once to look through the surface in an attempt to perceive the universal inner architecture. It was as though for the artists the body was opaque; for the medical students, transparent. The artists, moreover, were "distracted" by all sorts of nonstructures and adventitious appearances. They became fascinated, for instance, by the play of light on the silky webs that fanned out whenever they separated one bundle of muscle fibers from another. They noticed differences in texture and translucency and in their sketches tried to capture the pearly appearance of fat globules.

Obviously, the original human element had evaporated from both approaches. To demonstrate the extent of the divergence, it seems that the artists could not see the forest for the trees, though

they were acutely aware of the character and even the beauty of each individual leaf. The medical students probably knew more about anatomy in the sense that they understood better the mechanics and functional relations of the bodily parts. They also knew the names of more structures down to the most minute muscle and nerve twig. The artists, on the other hand, came away with an enormous repertory of shapes, colors, and textures and the global impression of the ingenuity and marvelousness of nature. But the artists had already forgotten, if indeed they ever knew, that the *extensor digiti quinti* does not extend the great toe — at least not often. The medics all seemed eager to remember this to their dying day.

What both groups equally and as quickly lost sight of was that what they were working over had once been a person like themselves. The artists lost this awareness in the richness of shapes, lines, and textures; the medical students, in the plethora of origins and insertions and Latin names. The artists, at Christmas, were not above putting holly and bells on the cadaver's fingers and toes, for which they were sternly reprimanded by the professor for their frivolity and disrespect. The medical students too had their little jokes. They were similarly rebuked for calling their cadaver "Mabel," and by rearranging parts of the body so as to confuse their partners.

Two points of view, two mental sets, right brain dominance versus left brain dominance — call it what you will — both groups had become equally detached from their initial humanistic awareness of a deceased human being. Though the schooling and interests of the artists were predominately humanistic, they were no different from the more scientifically trained medical students in this respect. Neither group ended up showing the least inclination to accept the fact that such a pile of discolored, pickled, fragmented debris had ever walked about, rejoiced, and suffered as they did. But these particular artists — one might object — as medical illustrators in training, were already part scientist and, therefore, desensitized and contaminated by the impersonal attitude everyone deplores when encountered in a physician. If this is the case, it might be interesting to imagine how open, responsive, imaginative, nondesensitized classical scholars or historians would handle the trauma of the dissecting table.

I believe their immediate response could not be different from that displayed by both medical students and artists when they first laid eyes on the body they were to dismantle. Scholars would see neither a puzzle to be solved nor a wonder to be appreciated, but simply a corpse and all that remained of the efforts and hopes of some poor soul's existence. Standing at the edge of this abyss, they would feel cold in their own bones and know the essential loneliness of all beings, the evanescence of life and its inherent, unsolvable ambiguity. But because such feelings quickly grow burdensome, they would soon do one of two things: either leave the laboratory, never to return, or do as the medical students and artists did. Their mental sets would change. They would distance themselves from the body and begin to perceive it as a thing—an object—to be explored from one or another point of view. By so doing, they would lose the wholeness of their approach and constrict the range of their emotional responses.

It would be unrealistic for anyone to lament this constriction if, as I believe, the only alternative is to escape the scene altogether. The more sensitive and esthetic sometimes drop out of medical school, if they find themselves unable to erect this defense. It is not improbable that in such individuals, the habitual cultivation of imagination through art and literature renders feeling ever ready to well up, and harder to contain. Yet, there are many vital, necessary tasks that, for the benefit of all of us, some group of men and women must carry out—tasks that would founder except under such conditions of emotional retrenchment as I have mentioned. There are many offices performed on, or with, other human beings that not only do not call for the involvement of the whole, feeling person, but which are liable to be accomplished much more effectively if all troubled personal reactions are kept under a tight lid. The automatic stifling of a certain range of sensibility in these medical students and artists is nothing less than a protective psychic screen. As such it is, I believe, a healthy and practical device for negating feeling responses that could only impede the goal at hand.

But I have cited the example of the anatomy lab and introduction to the cadaver only as an epitome. It is just the first, and not by any means the most harrowing, of many fearful experiences occurring in the career of a medical student and physician. Medical

practice requires its practitioners to do many things to the human body that, were they done out of any motive but the disinterested preservation of life and health, would be altogether objectionable on the grounds of perversity, cruelty, or obscenity. In order to master many procedures and operations students must not only be convinced that they are rational and necessary, but must also be willing to struggle with ingrained psychic resistances and inhibitions that are the offspring of dread and guilt. The nature of their profession demands that they be pushed, and vigorously, into much previously forbidden territory. To cause pain for cure's sake, to touch the naked bodies of strangers, male and female, to probe orifices, to cut living flesh, to extract blood, to inject and excise and amputate—all these commonplaces of medicine closely resemble, on one level of the mind, behavior that students from childhood on knew was unthinkable and, if thought about, abominable. Initially, they can only enter this domain by doing violence to these entrenched prohibitions and to their own sensibilities. Yet they must go ahead anyway, so they grit their teeth and override by main force their dread and pity and guilt. When the resulting tension proves insupportable, fledgling doctors, over time, progress from the condition of sternly suffocating and disregarding the disruptive feelings to that of detaching themselves from them altogether. Finally, a point may be reached where those feelings are no longer accessible to consciousness and no longer capable of trammeling the efficiency of the doctors. But the cost of this repression may be great for reasons to be mentioned.

The most desperate and acute way of handling painful situations—one *not* recommended for physicians—is to lose consciousness altogether. Escape by fainting may be nineteenth century but it *is* definitive. I recall only three students who used this method (one time each) in my class of ninety-eight men and three women. Both times the group was watching medical movies which, for some reason, make ordinary doings look horrendous. One was a film on childbirth—always grim in color—and the other, oddly, merely showed the use of the proctoscope. Two students keeled over when the episiotomy was shown and the other as the proctoscope was inserted. If you are guessing that the three who passed out were three young men you are astute. Nothing fazes female medical students.

Instances of outright fainting are rare, fortunately. Yet, I believe that there are times when physicians in every specialty must find it necessary to close the door firmly against their personal, subjective reactions, though less dramatically. For they are often plunged into situations that would evoke in the layman upsurges of horror, pity, despair, and so forth, of such intensity as to be shattering. It is altogether appropriate and desirable, therefore, that physicians have the capacity to turn their emotions off and to proceed as calmly and rationally as if they were working with test tubes in a laboratory.

Unfortunately, there is a serious hazard involved. To deny expression to emotions for too long a time is to risk their deserting us leaving us devoid of an important part of our humanity — our warmth and spontaneity. More than others, medical students as a group may be particularly prone to this calamity, for their personality profiles often tend toward the obsessive-compulsive type of which a characteristic feature is isolation of affect. The danger here is that a way of coping that serves admirably as a temporary expedient under stress may, in vulnerable individuals, grow to encompass all waking hours, imprisoning the feeling life as in a refrigerator. When this happens one encounters those fortunately not numerous Angus Duers of medicine who may function very well as technicians, businessmen, or computers but who, in no human sense, are capable of ministering to the sick or of giving heart to worried families. If there are ways to strengthen and safeguard young people against this ultimate induration of spirit, it is essential that they be found and used. These solutions seem to be especially pressing for students in medical school where overcontrol of feeling is a necessary hazard of the professional initiation.

Ideally, physicians should have resilient personalities with various and flexible psychic resources. This idealization means men and women who have as much access to their feelings as they have control over them, who can fire up and be moved intensely when it is called for, but who can also disengage themselves from emotion when it is to the patient's benefit and to the benefit of the task at hand. Emotional overinvolvement is as detrimental to good patient care as is coldness. Certainly, the therapeutic atmosphere should never be chill and austere, but rarely is it necessary for it

to resemble the finale of *La Traviata*. What is needed, by and large, is a middle way between these extremes—and not perpetual lukewarmness either, but a pliant and responsive interplay with circumstances as they change, veering as occasion dictates first closer to one extreme and then again approaching the other but not going on the shoals of either.

Some members of the dialogue group, notably Charles Rusch and Geri Berg, have called this poised position "dispassionate involvement"—an ability to empathize with the patient in his plight without suspending the faculties of objective observation and rational judgment. It is a noble ideal and achievable, I think, by most physicians under ordinary conditions of practice. Unfortunately though, in dire circumstances and extreme stress, empathy may seem an obstruction, and observation and rationality the chief things to be preserved. But ideally, medicine's full potential is reached only when physicians are as much human beings at the bedside giving care and comfort as they are scientists and technicians evaluating laboratory studies and doing surgery.

Clearly, in view of the aforementioned pitfalls, medicine's full potential is not to be reached easily. On one hand, it is essential for medical students to develop appropriate emotional armor if the practice of medicine is not to be an unending assault on their nerves, a perpetual trauma. On the other, they must retain their capacity to react and respond as human beings so as never to forget that their profession exists only for the sake of humanity and not for either their personal curiosity or their ambition.

Thus, there are important questions that ought to be answered: How can medicine, with its multiplying technology, safeguard its sensitivity and compassion? How can medical schools both protect the vulnerable quick of their students and at the same time preserve the equally vulnerable core of human concern that everyone agrees should be the heart of the doctor-patient bond? How can medical students be helped to develop the emotional breadth and control—the ability to respond appropriately and variously at a signal—that appears to be necessary in a field that is at its best an amalgam of science and art—that is, a partnership of objective thinking and subjective feeling?

As I have pointed out, art and the humanities in themselves neither obviate the need for a certain useful compartmentaliza-

tion of emotive life nor guarantee immunity to even outstanding figures in those fields from the kind of anesthesia of compassion that sometimes benumbs physicians. Most socialized adults distance themselves by denial and suppression from spontaneous feeling whenever it proves impossibly awkward or encumbering. As for great artists and authors, they often lead lives of unusual hardship and toil; in order to keep from going under, some of them feel forced to adopt an attitude of thorny cynicism, thereby protecting the work at the expense of their personal relations. Often this is deliberately done in the belief that future generations will benefit sufficiently from their productions to offset the prejudicial effect on contemporaries. The occasional insensitivity of artists is, therefore, no argument against the sensitizing influence of the arts.

All that these demurrers prove is this: no one is invulnerable. Sometimes narrow-mindedness, selfishness, or failure of empathy can overcome any of us, in spite of previous educational influences. Even the broadest and deepest intellectual and art experience, the outcome of a formative process imbued with the highest humanistic values, can render no absolute immunity to the constricting forces that produce our Angus Duers.

What the demurrers cannot prove is that physicians do not benefit from a more richly humanistic education than most now receive. "Expert men can execute and perhaps judge of particulars, one by one," writes Francis Bacon, "but the general council, and the plots and marshaling of affairs, come best from those that are learned." Obviously, physicians must be more than merely *expert* if medical science is to reach every octave of the human spirit while extending its benefits to the bodies of people of every place and every station. Beyond the capacity to auscultate the human heart of each individual patient, physicians ideally should have a genuine and ardent concern for the well-being of the race. A program of personal development replete in the humanities and deep in the arts, though not sufficient in itself seems nevertheless all but indispensable for many people.

If not sufficient in itself, what else then is needed? For one thing, healthier and more humane ways of training medical students is necessary. Before being accepted by their elders new college undergraduates must still, in some places, endure hazing and

hell week for limited periods during freshman year. But the hazing of fledgling doctors may, and usually does, last for a full five years. In this context, "to haze" is to harass by exacting unnecessary, disagreeable, and difficult work, accompanied by criticism, humiliation, and sleep deprivation. Not all of medical school is like this, fortunately, and most of the schools are slowly improving, in part as a result of strikes and rebellions by the students and interns themselves. It is high time. That the introduction of medical students to their profession often involves their being treated as tape recorders, automatons, drudges, and knuckleheads is surely cause for wonder that the schools have not turned out more medical machines like Angus Duer. That they have not is a tribute to the basically healthy personalities of most of the students and to the humanizing influence of many of the faculty—in my day, the older and wiser among them. Today it may well be the younger faculty who are the less remote and authoritarian.

These observations lead to the conclusion that the humanity of medical practitioners can be assured if candidates for medical school are selected on the basis of their possessing, to begin with, breadth of interests, a varied educational background, the capacity to be concerned about the emotional needs and general welfare of others, and a certain toughness and resiliency. Combined with these requirements is a need for teachers not only thoroughly trained in their specialities but also themselves broadly educated, cultured, and compassionate men and women, people who will see to it that the students themselves are treated with kindness, patience, respect, and encouragement. For one's mode of practicing medicine is acquired more through emulation than by cogitation, and the value of good models among the faculty far surpasses that of good lecturers. It seems to me that for every professor who is admired in medical school, there are likely to be two who are merely feared. And of the former, the better part unfortunately are admired for their scientific skill and knowledge primarily, and not because they are persons of sensibility and vision. Yet, I recall one professor who tried to inspire his medical students. Unfortunately, though, he made no effort to *instruct* them and the attempt of course failed. To inspire without teaching is quixotic and ludicrous, but to teach without inspiring is very nearly tragic.

As an example of the penchant of medical faculty for overlooking the human factor, I recall an episode from my own training. The class in question was designed to teach us how to do physical examinations and, over the course of many weeks, an absolute parade of august specialists discoursed on the techniques of every field. One after another of these specialists would inform us, for instance, of the thousand and one ailments diagnosable merely from a conscientious examination of the epiglottis. It is pertinent to my moral that everytime the proper way to auscultate a heart was presented it was demonstrated along strict sexist lines, that is, always on the topographically simple chest of some young man. By the time the experts were through, patients seemed as strange to us, and as full of dire pitfalls, as the jungles of the Congo. As a result, we were terrified to approach one. It happened that one of my first practice patients was a portly woman. Her breasts met in the midline and covered her entire upper torso, completely obliterating any trace of an orienting landmark such as a rib. I knew that to hear the aorta one placed the stethoscope precisely on the right second intercostal space; but how was I to find that space? Of course, I knew *anatomically* where to find it, but I did not know—so to speak—*socially* how to get to it. Not one of the experts had advanced so much as a hint regarding what the proper physician said or did in such a fix. Should I say, "Miss, kindly elevate your right breast"? That solution, however, seemed stuffy. Or should I boldly take hold of the obstacle with my own hand and push it up out of the way. That seemed gauche. Or should I first place the stethoscope on less problematic terrain— say, a little to the east of the umbilicus—and work my way up to the spot by burrowing? Alas, that seemed overcasual, not to say fumbling. In the end, I listened *through* the breast, but it might just as well have been through a wall. I felt then that, as a physician, I was a cowardly failure.

The humor is evident enough now, but it was not then, and I still believe such anxiety and embarrassment should be prevented. A course in medical etiquette might help but far better might be a practical illustration of the amenities involved by some tactful, well-mannered professor to serve as a model.

Clearly, the arts and humanities have a potent and central, yet unobtrusive, role to play in the experience of medical school.

They exert their warming and inciting influence from the background and subtly, through the impact on previously sensitized students of the cultivated, farsighted, and diversified personalities of certain members of the faculty. To a lesser extent, perhaps, they exert their humanizing power through the students also, those whose early energies were not spent on chemistry, physics, and microbiology to the exclusion of history, philosophy, literature, and art. But the humanities and the arts are conspicuously, and perhaps properly, in the foreground only during college days and before, and then again *after* the doctorate, when young physicians are settled and their practices underway. (I say *properly* in view of the great glut of scientific knowledge that the student must assimilate in four or five years, which unfortunately seems to leave little room for anything else). But once a going practice is assured, and the demands of patients plateau, a return of the suppressed is likely under the following conditions: first, if the physicians' premedical exposure to the arts and humanities was what it should have been, that is, moving and revelational; and second, if among their professors were at least a few capable of extending the necessary encouragement by providing, in their own persons, the quickening example. The first, and very likely the second also, seems almost to be an absolute prerequisite. If these prerequisites are met, the way is unobstructed; provided the physicians will only take the time, they can return to them throughout their lives to refresh themselves and clear and enlarge their vision.

Why one might expect the humanities to afford this refreshment and clearer prospect is obvious from their very nature. How love of the fine arts may enhance a physician's practice, however, is perhaps less clear, and I will briefly address my concluding remarks to that.

Music, painting, dance, and the rest, beyond any other effect they might produce separately and collectively, have one thing in common: They keep the feelings supple. If an individual does not respond to art with emotion, he simply does not respond to it at all, for the sense of beauty is an emotion. People who maintain an absorbed and ongoing contact with the arts are nourishing their affective lives to a degree commensurable with the vigor of their appreciation. I have stressed, as a hazard peculiar to medical

training, the protective and dangerous freezing that occurs in the face of repeated assault on one's sensibilities. Well, art, in the receptive, can thaw what trauma freezes; it is like a sun that conjures moods and colors perceptions the way summer days conjure and color flowers. The physician who never misses the chance to view a Rembrandt masterpiece or experience a Mozart sonata is unlikely ever to become wholly divorced from the deeper currents of humanity.

Many physicians complain that medical practice consumes them, that it leaves them no time to enjoy anything else. And it is true that physicians, on the whole, burn themselves out and die prematurely. A love of art, however, may contribute to longevity, for art alerts the senses and makes the wider world a place one wants to take time to see and to savor. "A man that has a taste of music, painting, or architecture," writes Addison, "is like one that has another sense, when compared with such as have no relish of those arts."

Nor will patients suffer in the long run if doctors take reasonable vacations—not to mention the benefit vacations will bring to their families. For if they take a break occasionally, they will not only remain awake and receptive and probably last longer but, with their psychic needs for breadth and depth fulfilled, they will be less apt to seek comfort in those fatal coves of the overworked and undergratified: drinking and drugs. "Industry without art," says Ruskin, "is brutality." It seems to me that comment would be an appropriate motto to emblazon over the portal of every medical school in preference to "Abandon hope, all ye who enter here."

As an art historian who has taught in a medical setting, I have tried in this paper to give some idea of the variety of contributions visual arts can make to medical education and what art can mean for the personal and professional lives of students in health professions. To this end I have chosen to examine the Rembrandt painting, The Anatomy of Dr. Nicholaas Tulp. *This painting raises some important questions about the way art can focus our experience and impact on our lives. I have also chosen to include the painting as illustrative material for exercises involving nonjudgmental observation, critical inquiry, and emotional, as well as cognitive awareness.*

4

The Visual Arts in Health Professional
Education: Another Way of Seeing

Geri Berg

When those involved with art, whether they be painters, critics, or historians, are questioned about the relationship of art to medicine, they may cautiously offer the area of medical illustration as one possible link between the two fields. Students and practitioners of medicine are sometimes more imaginative, but equally hesitant. In addition to medical illustration, their list might include media of all kinds (audio, visual, and printed) that have helped to supplement a lecture or provide health education for a patient. Art collections of famous doctors, famous doctors who are artists, and personal art activities "on the side" are also

mentioned by those in the health professions when pondering the relationship between art and medicine. Art therapy can be added to their list, as well as the use of children's drawings as diagnostic aides by those in pediatrics. The concept of the "art" of medicine is also considered, and although usually vague, it is given to mean anything from a certain excellence of technique to an undefineable element of exceptional medical practice.

But what is meant by the suggestion that art may contribute to the education of the health professional is still unclear to many. Medicine and physicians have a long history of benefiting the ideas and craft of the artist, although contemporary artists are often ignorant of this historical liaison. But to contemplate the contribution of the arts to medical education, we need at a minimum, definitions for "art," "education," and "health professional." It appears easy enough, although somewhat arbitrary, to define what we mean by the arts, particularly if we choose to limit the definition to the visual arts. In this case, the study and knowledge as well as the practice and experience of painting, drawing, sculpture, the crafts, architecture, photography, and film could be included, based on the visual dimensions of each and their customary inclusion in the fine arts. But can we and should we include the related areas of city planning, the study of perception, the area of visualization and healing, certain aspects of the public media or even the visual dimensions of the dance within this definition? It is quickly apparent even here, that the usefulness of any definition of the visual arts will depend less on exclusionary criteria, and more on how each of the arts to be included will be used.

Furthermore, we can decide to define a health professional as one who participates in a regularized and authorized course of study and training which prepares one to serve the health needs of others. This category would include such persons as physicians, nurses, nurse practitioners, and mid-level health professionals, such as physician assistants. But we may also want to make the case for persons in such fields as radiation therapy or social work. We could likewise limit "education" to those years of formal study which lead to accreditation in these fields, but still not want to devalue the importance of preprofessional, postgraduate, or continuing education.

The problem is obviously more than just a matter of definitions. Rather, we need to articulate what the visual arts intrinsically have to teach any of us and from that point investigate what might be particularly relevant and humanizing for individuals involved in health care. Questions of curriculum time, priorities of learning, and "essential" information will be as endlessly debated by students and faculty as the answers to these questions are endlessly changing. I believe that our goal is simply—or not so simply—to open the door to another perspective on learning; to see what the methods and materials of a humanities discipline may have to offer to the process of becoming a health professional. In short, to examine just what contribution the study and experience of the visual arts can make to the understanding of our patients and ourselves. The case for inclusion in valuable curriculum time will have to be made personally and collectively and in concert with innumerable other considerations.

Art is, of course, an activity or craft as well as a visual, tangible object. The experiences out of which art is created are generally a fusion and a reflection of the social, often the political, and always the personal life of an artist. For the viewer, the art object can provide the stimulus for many things: analysis, scholarly study, or criticism; deeply experienced emotion whether positive or negative; identification with the artist's experience or self-reflection. When we speak about the study of the visual arts in a health professional curriculum, it is helpful to keep in mind this full spectrum of what art is. It is precisely because art is so richly complex that our possibilities for learning from it are endless.

Sometimes the value of an analytic, interpretive approach to a discipline is easier to see than the equally important experiential component to learning. And although different, these approaches are complementary ways of learning. A course on the community and medicine may be used as an example. Documentary photographs from the early part of this century could supplement such a course as a means of understanding the social problems of another time. But one artist-physician, Eric Avery, who has written elsewhere in this volume, suggests that there is also much to be learned by using our own cameras and "focusing" on the neighborhoods around us. In this same area, even a limited study of the history of town planning may provide perspective on how

the architectural environment influences the health and well-being of citizens in ours and other cultures. Likewise, to participate in the actual design of a neighborhood health clinic, either as an exercise or as part of a community group planning such a project, brings present reality to this historical material. The collective life of a community is often expressed in its mural art, which has a long and interesting history of decorating public space while at the same time proclaiming community values.[16] Another way to learn about a community's health is through the study of its local public art, a kind of "community case study." This knowledge could again be further enhanced through participation, where possible, in the actual design and creation of a mural that reflects the beliefs and values of a community of which one is a part.

Optimal learning situations are still ideal and not always possible, and we are not interested in this context in becoming accomplished photographers, architects, or mural artists. We need only to recognize here, as in many aspects of medicine, the importance of an experiential component to our learning and for including it wherever possible. These experiences with art as an activity not only serve to concretize theoretical knowledge but also enrich classroom interaction and discussion. The focus in the classroom, however, will necessarily be on what can be learned from the art objects themselves.

Diane Arbus, an American photographer who died in the 1970s, has been quoted as saying: "I do feel I have some slight corner on something about the quality of things. I mean it's very subtle and a little embarrassing to me, but I really believe there are things which nobody would see unless I photographed them."[17] Do artists have a special way of seeing? Does art focus our experience in ways that are enlightening, more satisfying, or disturbing to our notions of reality? Can we learn from artists how to become better observers, to see more critically? To explore the idea that an extended encounter with the visual arts can, at a minimum, help to sharpen our observation skills, let's begin with an exercise.

Take a few minutes to look at plate 1 (p. 52). Ask yourself the question, "What do I see?" Try to describe what you see as simply and straightforwardly as possible. For instance, which of the following phrases best describes this picture:

 a. eight doctors observing an operation
 b. a Dutch group portrait of the seventeenth century
 c. several clothed men surrounding a prostrate body
 d. a university professor addressing his colleagues
 e. eight identical men with one man lying down in the foreground

Or which of the following phrases best distinguishes the man on the right of the composition from the others:

 a. his arrogant appearance
 b. his clothing
 c. his superior knowledge
 d. his status in the community
 e. his earnest expression

If answer "c" in the first case and "b" in the second were chosen, the answers were based *only* on observation, on what can be seen. The other answers (some are correct, others are not) all depend on prior knowledge, interpretation, or assumption about what is seen. What we see is a group of men with a variety of costumes—one of whom is seminude, another who is wearing a top hat; an open book in the lower right corner; an ambiguous architectural setting (is it indoors or outdoors?); men looking in different directions, and so forth. The correctness of an interpretation of the role of these men, the reason they are assembled, or the status of the man with the top hat will ultimately depend on additional information.

The second part of this exercise involves asking questions based on what is seen. What questions would you ask that would tell you something about this scene and would at the same time give the *most* information per question asked? For instance, consider the following list of questions:

Who are these men?
Who is the artist?
What is the name of the man with the top hat?
Are these men doctors?
Is the prostrate body a cadaver?
What is the setting?
What is the name of the painting?
Why are some men looking in different directions?
What is the significance of the instrument depicted?
Why are these men assembled?
What School does the artist belong to?

What is the date of this work?

Why did the artist paint this scene?

Is this a demonstration of the pronator muscles of the forearm?

Why is the face of the man lying down partly in shadow?

What is important about the body?

Why are there no women in this painting?

Why is the book open?

What is the name of the man lying down in the foreground?

Why are all the men dressed in black?

Clearly, answers to broader questions like "what is the setting?" and "why are these men assembled?" would be quite helpful in such an investigation, while others that could be answered by only yes or no, like "is this a demonstration of the pronator muscles of the forearm?" or "is the prostrate body a cadaver?" would be less helpful. Beyond this point one must carefully consider which questions to use and why: whether the answers would significantly contribute to an overall understanding of this scene.

The ability to make nonjudgmental or noninterpretive observations (part one of the exercise) as well as the ability to ask precise and insightful questions based on what is seen (part two) is important to both the study of art and the practice of medicine. There is, of course, an essential role for interpretation of what is seen as well. But perhaps both historians or art and practitioners of medicine would agree that the danger in too much intrepretation based on assumption is not only that we may be wrong, but that we may continue to make judgments based on erroneous early information.

There is, however, more to art and medicine than well-practiced observation and critical inquiry skills. The "something more" involves a total response on our part, an emotional as well as cognitive response. Look again at plate 1 and try to recall your response to this scene when you first saw it. Were you aware of having any feelings at all about this painting? Do any of the following words fit your feelings as you look at this work now:

intrigued	anxious
bothered	repelled
excited	inspired
curious	puzzled
enthralled	disturbed
bored	

Do your feelings about this picture arise from what you see; your particular mood at this time; your professional identity; sympathy with or rejection of this scene? It is sometimes difficult to differentiate between what we intrepret to be the "message" of the work of art and the feelings that this message evokes in us. It may be harder for some to describe their feelings when they are familiar with a painting, for instance, or for others, when they are unfamiliar with it. The practice, experience, and study of art, like medicine, involves our emotions. Both art and medicine may be removed from this realm of subjectivity, intuition or feeling, but not without some sacrifice. Many practitioners acknowledge that allowing themselves an emotional interchange with a patient changes them ever so slightly, making it possible to interact with the next patient with all that was learned from the first, and so on. Artists and their art function in the same way, as does the viewer and the work of art when some kind of emotional involvement takes place. This is why it is so important to view the work of art or the patient as something more than just a source of information or data.

To be fully conscious of one's emotions and to be able to discriminate between feelings that come from one's own values and world view, those engendered from an outside stimulus, and those that arise from an interaction of the two is not a skill necessarily acquired easily. Emotional awareness, like observation and critical inquiry skills, is an important part of providing good health care, and one way that art can help to teach us more about ourselves and our impact on others.

The facts of the Rembrandt painting referred to in the previous exercise can be briefly stated. It *is* a Dutch group portrait of the seventeenth century. In 1632 Rembrandt was called from his home town of Leiden to Amsterdam to paint the portraits of these men from the Guild of Anatomists and Surgeons. *The Anatomy Lesson of Dr. Nicolaas Tulp* (located in the Mauritshuis, The Hague) was an important commission which helped to launch the young Rembrandt's successful career as a portrait painter in Holland. The open book in the lower right corner is an anatomical text; the setting is a makeshift theater, a grain-weighing house in Amsterdam where that year's public anatomy was held. (Rembrandt's painting was destined to hang in the new Anatomical Theater

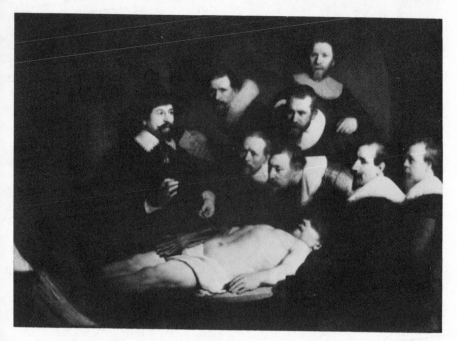

PLATE 1 Rembrandt van Rijn, *The Anatomy Lesson of Dr. Nicolaas Tulp,*
1632.

Courtesy Mauritshuis, The Hague.

PLATE 2 *Madonna* (detail),
sixth-seventh century. Saint
Francesca, Rome.

Courtesy Instituto Centrale per il Catalogo
e la Documentazione.

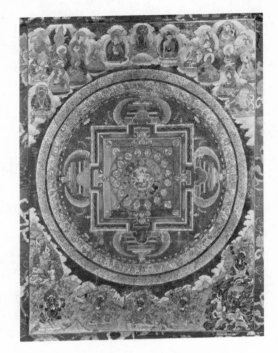

PLATE 3 Tibetan Tanka, *Maṇḍala of Samvara–Sita-tapatra Aparajita*, eighteenth century.

Courtesy Asian Art Museum of San Francisco, The Avery Brundage Collection.

PLATE 4 Diego Velázquez, *The Maids of Honor*, 1656.

Courtesy Museo del Prado, Madrid.

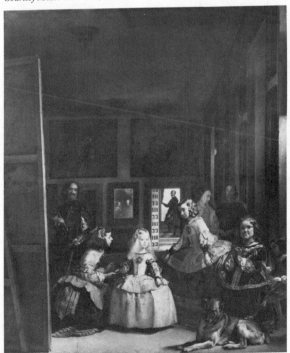

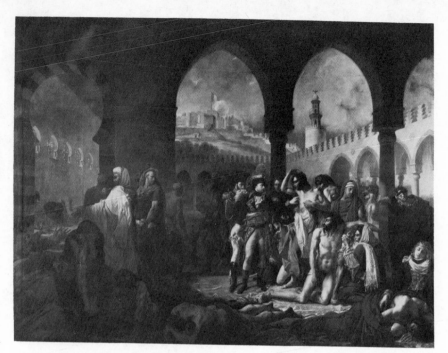

PLATE 5 Baron Antonie-Jean Gros, *Napoleon Visiting the Pesthouse at Jaffa*, 1804.

Courtesy Musée du Louvre, Paris.

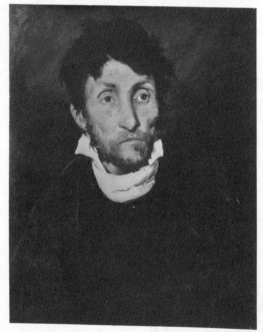

PLATE 6 Théodore Géricault, *Portrait of an Insane Man ("Kleptomaniac")*, ca. 1822–1823.

Courtesy Museum of Fine Arts, Ghent.

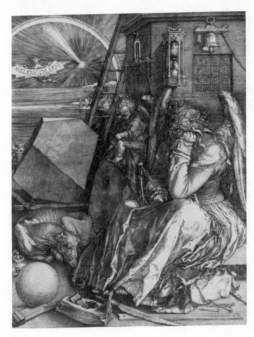

PLATE 7 Albrecht Dürer,
Melencolia I, 1514.

Courtesy Philadelphia Museum of Art.
PURCHASED: THE LISA NORRIS
ELKINS FUND.

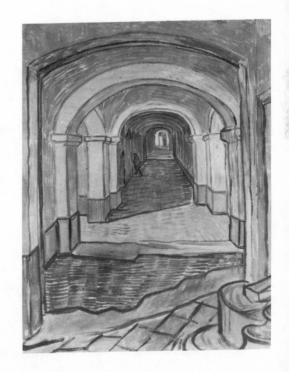

PLATE 8 Vincent van Gogh,
*Hospital Corridor at Saint-
Rémy*, 1889. **Courtesy Col-
lection, The Museum of
Modern Art, New York.**

Abby Aldrich Rockefeller Bequest.

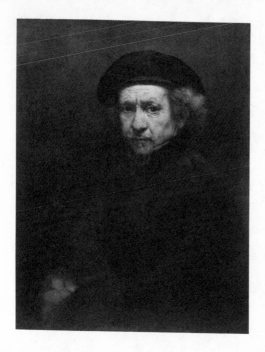

PLATE 9 **Rembrandt van Rijn,** *Self-portrait,* **1659.**

Courtesy National Gallery of Art, Washington, Andrew W. Mellon Collection.

PLATE 10 **Pablo Picasso,** *Artist and Prone Woman,* **1971.**

Private collection.

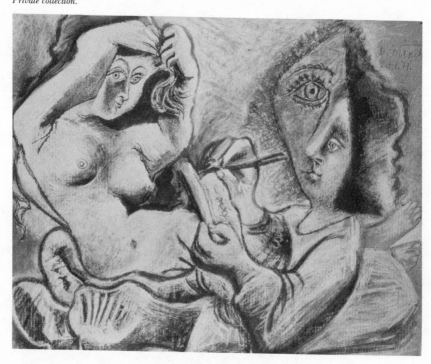

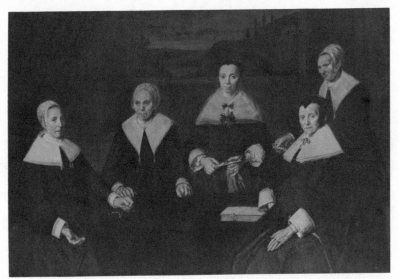

PLATE 11 Frans Hals, *Regentesses of the Old Men's Home, Haarlem,* ca. 1664.

Courtesy Frans Halsmuseum, Haarlem.

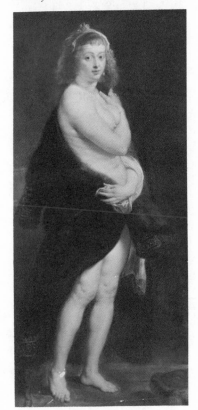

PLATE 12 Peter Paul Rubens, *Hélèna Fourment with Fur Cloak,* ca. 1638.

Courtesy Kunsthistorisches Museum, Vienna.

under construction at the time and finished in 1639). The man with the top hat is Dr. Nicolaas Tulp, the chief anatomist and surgeon for Amsterdam and the only physician in the painting. We know quite a bit about Dr. Tulp, not only that he was presiding over his second Annual Public Anatomy, but also that he was a well-liked and respected general practitioner, that he instructed midwives, and that he was active in city politics and civic affairs.[18] We even know something about the cadaver. His name is Aris Kindt. He was a criminal freshly hanged for this event, and it seems as if his crime was stealing the cloak of an officer and then attacking a jail guard when his trial was delayed. The Annual Anatomy was in itself quite an occasion. It occurred at the beginning of the winter solstice and lasted four or five days. Tickets were sold, handsome profits were made for the guild, and it was a "social must" for all visiting dignitaries. We are to imagine this scene taking place before a crowd of hundreds, with the front row seats reserved for physicians over age fifty. The persons in the audience were admonished to ask only questions of "a serious nature" and there was a stiff penalty for anyone caught stealing parts of the cadaver as they were passed around.[19] On one level, the scene is a celebration of learning, of modern science, and modern medicine. Although still with its moral and even quasi-religious overtones, the "Annual Anatomy" has gone public. The forbidden dissection of the human body so long carried out in secret in church and hospital basements has quite literally seen the light of day. This painting represents a fascinating blend of art, medicine, history, science, and social customs, and provides a re-markable means for studying the impact of these fields on one another.

But on another level, this painting represents a profound challenge to many of our cherished beliefs and values. What we see before us are eight finely-dressed gentlemen posing for their por-traits in front of a dead man. This corpse, or cadaver, occupies a prominent position in Rembrandt's painting. In representations of this event by other artists, the cadaver's place is inconspicuous, dwarfed by the activity and personalities around him. In this work, the cadaver lies in a strong shaft of light, like a diagonal slash across the composition. Its presence is confronting and una-voidable. What did Rembrandt intend for us to think about when

we looked at this painting? Was he trying, amidst the finely dressed gentlemen and the learned Dr. Tulp, to remind us of what was once the personhood of the dead man? Was it then, as it is now, that cadavers more often than not come from the ranks of the poor and the so-called criminals?

For anyone even slightly familiar with Christian art before the seventeenth century (as Rembrandt certainly was), there is an uncomfortable familiarity in the placement of the cadaver. It occupies almost the same position as Christ does in portrayals of the "Lamentation": the mourning of Christ's body after having been removed from the cross by his mother and closest friends. Are we intended to think of this cadaver somehow as a martyr? Even as the day is dawning on a new era of scientific medicine, is there a price to be paid—in our callousness towards the human body, in diminished respect for the dead, in a reduction of our humanity? Was Rembrandt reminding us (as art at its best can do) of the contradictions which plague us all, the problems inherent in "progress," the fundamentally ambiguous nature of life? Rembrandt still acknowledges in this painting, the prominence of the men, the dignity of the gathering, the importance of the event. But he is also not letting us dismiss the figure central to this composition and to the event itself. And whatever Rembrandt intended, we are still left with our responses to the work, our possible uneasiness at what we see and our willingness to become involved with the issues presented here: issues concerning our attitudes towards the dead and how they serve life; towards our own death; our concepts of the "lived" body and the "object" body to use the philosopher's terms;[20] our concepts of science and medicine; notions of progress, ritual, and even justice.

Ultimately, to have any real meaning for us, art must help us to focus our own experiences and sort out our values. It can do so in many realms; in our concepts of health and illness; in our attitudes towards the body, aging, sexuality, or the family; in our understanding of the complexities of the human life stages of childhood, adolescence, adulthood, and old age; and in our grappling with the processes of dying and grieving.

Plates 2 and 3 represent art objects that have been used for centuries in the healing process. The one (plate 2) is an icon with origins in the Vera Icon[21] and the beginnings of the Christian

religion. The icon, a detail of the Virgin Mary, represents a power outside of oneself that can be called upon in times of need. People pray to this art object, asking Mary as intercessor to God to give strength to overcome illness. There is a kind of magic about an icon, as if one could gain access to the power to heal through this image. Medieval reliquaries, which contained the bone of a saint or a fragment of his/her clothing were proclaimed to possess the same mysterious healing powers.

The second art object (plate 3) is a mandala with origins in eastern (Tibetan) religious art. A mandala may be thought of as a structural model for wholeness and for the universe. It represents or embodies the concepts of centering, the center, balance, focus, and concentration. It is used in meditation and considered a vehicle for concentrating the mind, for releasing the healing energy or power within oneself. The notion of using the mandala as part of a meditative, healing ritual can also be found in the Navaho curing ceremony of today where the patient sits at the center of a great sand painting that represents the cosmos and the universe in harmony.

Although the expected result may be the same (the restoration of health), the icon and the mandala represent fundamentally different approaches to healing, to health, and to illness. In the former, the focus is outwards, to a power outside of oneself as the cure and sometimes the cause of an illness; with the latter, the search is inward toward oneself as the source of one's illness and recovery. Comparable foci, of course, exist in medicine today and in our own attitudes toward healing, whether or not actual art objects are used. In some cases these objects are still used. Two examples are the crucifix in modern Catholic hospitals and the Lamaze "focus" object in the labor rooms of couples trained in prepared childbirth methods. To become fully conscious of these values may free us to listen more openly to the values of others, make us less likely to look with muddled bias on another person, and help us open ourselves to alternative ways of thinking about the healing process.

Artists have variously represented disease and both physical and mental abnormalities in art. Some of the important questions here have to do with the reason and occasion for their choosing to depict these subjects. Do these depictions represent a personal

view of the artist's affliction or are they a social statement? What kind of commentary is being made by artists about the health conditions, status of medical practice, societal attitudes or ethical values of their time? How do they illuminate the values of today? What can we learn from the dwarfs in Velázquez's *The Maids of Honor* (plate 4)? the plague victims in Gros's *Napoleon Visiting the Pesthouse at Jaffa* (plate 5)? or from the extraordinary series of portraits Géricault made of the mentally ill (plate 6)—intended as objective illustrations of types of mental derangements, but in the end, powerful portraits of human suffering and dignity?[23]

In plate 7, the German artist Albrecht Dürer shows us a portrayal of *Melencolia I* in an engraving of 1514. Through a careful study of this picture and its wealth of symbolism,[24] combined with a study of the literary and medical texts of the period, one could develop an idea of at least Dürer's conception (if not his culture's) of "the most ill-mixtured," hated, and feared of the four humors, the melancholic condition.[25] One can almost read this engraving like a textbook, i.e., the keys, usually a symbol of power and wealth, hanging useless at Melancholy's side; the dog and the bat, as symbols of darkness and depression; the comet from Saturn, capable of causing floods, the magic square, as a talisman to attract the healing influence of Jupiter; and so on.[26] Some have even proposed that this engraving is a kind of spiritual self-portrait of Dürer himself and advanced the notion that all outstanding persons, particularly artists, are melancholic.[27]

But in van Gogh's portrayal of the *Hospital Corridor at Saint-Rémy* (plate 8), an institution in southern France where he was a patient, the concept and the impact of depression is altogether different. It is both subjective and personal. Van Gogh speaks as an insider, of the loneliness of the long, empty corridors with only a solitary figure (himself?) disappearing into one of the endless look-alike doorways. He paints, in one way, to gain control and to make sense out of this personal experience; but he also paints to share those feelings with us, and to remind us that medicine ultimately has less to do with categories and symbols than with the suffering of a single, unique human being.

In conclusion, it seems that artists are always reminding us about the contradictions in life, as in these last examples of the artist's view of aging. Rembrandt, in a late self-portrait (plate 9),

depicts his own advanced years as a time of quiet introspection and stillness. Picasso, on the other hand, in the *Artist and Prone Woman* (plate 10), insists on a view of himself at age ninety as full of vitality and sexual prowess. The seventeenth-century Dutch artist, Frans Hals, portrays in his *Regentesses of the Old Men's Home, Haarlem* (plate 11) the stern, austere old ladies who were the guardians of the poor at a time when he himself was eighty years old, poverty stricken, and subject to their charity. And, finally, Rubens paints in the last two years of his life, a portrait of his wife, *Hélèna Fourment with Fur Cloak* (plate 12) as an older woman. It is a portrait of wrinkled flesh and less than ideal features, of surprising shyness and modesty—a rare exception in the history of female nudes in Western art.[28]

By presenting us with alternatives to our stereotyped notions of old age, these artists are reminding us that everyone is ultimately an exception, and that to understand human experience for aesthetic or medical purposes is to understand its uniqueness as well as its universality. It is one of the most engaging and important aspects of art that it requires us to examine our own beliefs and experience with respect to all that we hold precious and meaningful to our individual and collective humanity. It is in this way that the visual arts, as another way of seeing, can make their best contribution to the wholistic education of health professionals.

As a clinician, my interest in the relevance of the visual arts to medicine is from the perspective of a professional problem-solver. In this paper I plead not for additions to an already bloated educational experience, but rather for a reduction of the morass by defining and evaluating more specifically what instructors need to teach. I begin with a statement to the artist regarding clinical skills acquisition as currently taught, presented in such a way that the artist-educator can recognize areas to be exploited. Then I suggest to the clinician areas in which visual arts are already being used, with the anticipation that the imagination may be similarly unleashed.

5

Visual Arts and Skills Acquisition

John Burnside

To The Artist

The traditional rite of passage for a clinician begins with a six-year period of fact acquisition. Two years of medical school are tacked onto four years of college preparation for the refinement of that body of facts. Although latitude exists for other explorations, the emphasis is on the scientific method: hypothesis testing, experimental design, results and conclusions. Towards the end of this period of didactic learning, pattern recognition and departures from the normal are introduced. The clinical years commence during the third year of medical school. Even though

the human subject is introduced, pattern recognition and the scientific process still prevail. The excitement and reward engendered at this juncture are that the pattern exists in human beings and can be seen, felt, and heard. Congestive heart failure really does affect patients in a predictable pattern, and therapeutic manipulation really does cause the predicted changes.

A recognition of variance begins to appear. Students quickly recognize that clinical medicine is practiced differently by different people. Most entering medical students would be unable to state just what a neurologist, genitourinary surgeon, or opthalmologist does. In the clinical years sampling and observation of several medical specialities become evident. Students hear the siren call of a special discipline—or more likely, that of a special clinician. The result is a decision for residency training.

Students' initial thrills of having thrown their fortune in the direction of a calling are soon displaced by the monotony of pattern recognition: "All congestive heart failure is the same." But if a resident can persevere through the sameness, he eventually discovers the differences. Mature practitioners recognize that the real challenge is in the individual uniqueness of the human presentation of the pattern. A good teacher can use the same patient to excite junior medical students with the sameness of congestive heart failure and the seasoned resident with the special nature of that presentation.

In summary, it appears that learning during the pre-clinical years can be described best as "knowledge which can be acquired by description or instruction."[29] Such terms as concepts, paradigms, communications, search strategies, experimental and survey methods, and group processes are descriptives which apply to this phase. Learning during the clinical years as biologist Bernice Wenzel points out, involves "knowledge which cannot be acquired without direct acquaintance or experience." Descriptives for this learning include self-knowledge, similarities and differences, risk preferences, limitations, emotional limits, recovery from failure, accountability, styles, and values. Clinical training involves direct acquaintance and experience and can, I believe, lead to creative problem solving. By this term I mean the accurate synthesis of a process (diagnosis) even though a student may never have encountered a patient with that particular disease.

The skills of clinical medicine to be learned are not only motor skills, but processing skills, judgment skills, and humanistic skills as well. It is in this area of skills acquisition that I am most interested in applying the visual arts. The motor, or "how to," skills require repetitious practice following instruction. Visual aids, particularly audio-visual self-instruction packages, have been used in this area.

The connection of visual arts with processing skills is less obvious. Processing skills entail manipulation of raw data into patterns and sequences. But here, I believe, observation is the linchpin. First one must consciously collect the various stimuli presented to the senses: visual, tactile, auditory. A decision must be made to snatch pieces from the background noise of signals. This activity implies first order discrimination. This consciously acquired observation is then available for storage, comparison, and recall.

When the circuitry becomes facile and automatic enough, perception is possible. Recognition can occur with fewer signals. If the same number is collected, the result is ever-expanding cognizance. For example, observing a patient begins with the decision "I will look at him." "His eyes bulge, there is a swelling in the neck, and he trembles." Later, when this observation is processed with other clinical skills, the question becomes "what can I do for that hyperthyroid man who is depressed and frightened?"

Processing skills culminate in a decision requiring the skill of judgment. One of my colleagues has defined clinical judgment as making decisions based on incomplete data. While this may be true in the sense that the data may be soft, poorly defined, nonnumerical, or under the rubric of "gut feeling," it is nonetheless essential for a complete diagnosis and subsequent action. One of our educational failures is a lack of serious recognition and attention towards the "gut feeling" or inclination of common sense. Perhaps because this inclination is nonnumerical it is glossed over as the "art of medicine," implying instinct, passion, or the primeval. But I believe it can be defined and should be taught.

It is to be hoped that the artist-educator might help people with their fear of creativity. While those in medicine often laud creativity in general, they feel uneasy with the concept when applied to patient care. Creativity in this context usually connotes "tinkering" or deviation from accepted medical procedures. Instead, it should

mean a larger net for data gathering and more acceptable options for action.

Similarly, people need help in recognizing the discipline and science of art. Clearly artists have great facility with motor skills, processing skills, and judgment skills, as well as humanistic skills (which I will discuss further). If individuals can learn to recognize the common language between art and science, then medical education might escape some of the inertia of tradition, and so become less categorical, less reductionistic, and more attuned to individual human qualities.

To the Clinician

Let me first share with you a few comments of others in the dialogue group:

"Students need education or training as competent medical practitioners, as concerned, knowledgeable members of society, and as responsible, energetic, satisfied individuals." (Wenzel)

"Although the art of medicine is frequently alluded to, this thesis is never explained or integrated in the physician's training." (Cody)

"Art is an essential component of human culture and not merely a luxury. Art should be an intrinsic part of our education. . . . Art can be made a functional, meaningful, and relevant part of medical education." (Vastyan)

These statements may lead one to ask if art can be defined or used to teach medicine. Do the visual arts have a role in preparing competent practitioners, knowledgeable members of society, and energetic individuals?

Several frustrations and dilemmas evolved during the dialogue sessions. One member despaired of ever discussing nonverbal phenomena in verbal modes. Others argued that if these discussions could not take place, there could be no learning, no communication. Throughout the sessions, there was a push-pull of pragmatism versus hypotheses. Just as I asked the artist-educators to become verbal and pragmatic, I must ask my clinical colleagues to

stretch their minds and imaginations and exercise the other half of their brains.

Clincians each have a slide file of clinical material—visual representations of things to be taught. Each has sketched findings in a patient's record. Each uses visual thought during the clinical examination of a patient. Some examples include the appearance of structures under the hand or stethoscope, communications or body posture and gait, and clues as to skin color.

Consider the visual arts in acquiring the processing skills of observation and perception and the skills of judgment. Most importantly, consider how the visual arts could be used in the acquisition of humanistic skills.

We struggle to understand the concepts of accurate empathy, nonpossessive love, and congruence as described by Carl Rodgers,[30] and the skills implied in these concepts—empathy, perceptiveness, discrimination, tolerance, even-mindness, commitment, and self-awareness. Since explicit attention to these skills is not given in the preclinical years, instructors rely on the preceptorial concept of clinical teaching to do the job. An intuitive recognition of these skills has convinced us that they can be learned, in part, by example or role-modeling. Instructors are delighted when students respond to such modeling and show these skills in return. When humanistic skills do not surface students are criticized in evaluations as "brusque, superficial, humorless, mechanical, etc." Yet, I believe that the basic potential exists in everyone. It is the failure of the instructors, not the students, which prohibits the expression. We as clinicians should try not to be apologetic for our humanness. It is after all the interface of humanity and science which makes our profession so special. I believe that art both represents and teaches us more about our own humanity. I agree with one member of our group when he stated, "Often when appearing to be expressing newness, art is a reasserting of the values, forms, and ideas that are very ancient . . . resonating with the depth of man's unconscious."

An Experiment

Eric Avery, whose beautiful photographs appear in this volume, spent several months at the Hershey Medical Center photograph-

ing clinical activities. His extraordinary art results from selecting the right moment and composition. Combining his technical skills as a printmaker with his photographic work, Dr. Avery left us with a portfolio of rich teaching material. Those who participated in this project were affected both directly and indirectly in significant ways. Those who were the subject of his photographs made discoveries which affected their self-image. These discoveries ranged from the recognition of roles that were being played to a greater understanding of relationships with others, both peers and patients. For others, the portfolio contained startling examples of the invasion of personal space, touching, body language, uses of power and pathos, missed clinical data, and images of human beauty.

As an art historian I have followed with interest fairly recent attempts by artists and educators alike to create a novel, holistic model for the visual arts —a goal heralded as a "corrective for the overwhelmingly verbal nature of most of the educational institutions." In this paper I concentrate on the origins and nature of the transformation of vision as expressed in twentieth-century art. I believe that the extent of this transformation of vision is as significant as that of the Renaissance. The radical quality of this art lies in its overthrow of the influence of a verbal mode of experience in the visual arts and the definition of its own proper language. Therefore, a recognition and understanding of the nature and function of the language of art may prove beneficial to certain areas of medical education.

6

The Transformation of the Language of Vision

W. Sherwin Simmons

In his preface to *The Language of Vision*, S. I. Hayakawa wrote, "Whatever may be the language one happens to inherit, it is at once a tool and a trap. . . . Every language, like the language of the thermometer, leaves work undone for other languages to do."[31] This statement seems particularly appropriate to a discussion of the relationship of medicine to the visual arts, especially in an examination of congruities and incongruities of the two disciplines' languages. In this examination we have sought to explore the structures and basic assumptions of each language hoping to find what it is that they *do;* what are their limitations, both real and conventional; and ultimately how each can possibly be used as

a tool to free the other from certain traps in which it has become ensnared.

Dr. Hayakawa's trope of the thermometer is employed in the context of a discussion of the usefulness and limitation of language. All language, whether verbal or visual, is a response to the vast sensory experience of the world, an abstraction that attempts to form that wealth of experience into significant patterns of meaning. However, different languages approach this problem in very different ways. Certainly there are distinctions that can be drawn between the language of the scientific side of medicine and that of the visual arts. Rudolf Arnheim has made this statement clear in his discussion of the different attitudes and approaches of science and art.[32] This difference is exemplified in Dr. Hayakawa's trope of the thermometer.

The thermometer is, of course, an instrument used by science and medicine, whose quantitative language supplies an appropriately exact measurement of the body's temperature. The physician uses the data provided by the level of mercury in the tube relative to a numerical scale in a way that is characteristic of science's use of sensory information. That is, the reading is understood as an index that reveals a hidden condition in the body. It is only the signified condition that is important; no importance is attached to the direct response of the individual physician to the image of the thermometer. It is as if the signifier were transparent. An instrument is used for the specific purpose of reducing the possible error of direct and individual experience and making the reading scientifically accurate. The thermometer is only one of many scientific procedures and instruments employed to quantify that hidden condition in the body; and all are structured so that direct individual experience is transcended. One possible consequence of this necessary dependence upon scientific method is a diminishing of the credibility given to the uniqueness, richness, and ambiguity of direct experience. If sensory information is continually treated as a quantification of an unseen objective condition and if the data is constantly being related to known patterns of particular illnesses, then care must be taken also to maintain attendance and openness to the immediate experience of individual perception.

At this fundamental level of response to sensory information, the language of art differs from the scientific processes of medi-

cine. Art is rooted in the directness and the unique individual nature of perceptual experience and creative response. Rather than asking that each individual experience be transcended and synthesized in the establishment of an objective situation, art values the variety and immense range of possibilities within the phenomenal experience. Each artist in making an image fixes a set of significant relationships in time. Depending on various factors, the image may be seen and understood as having a certain correctness and truth, but that truthfulness may have little to do with a scientific standard of objectivity. For instance, there are numerous instances of paintings being done by different artists of the same motif at the same time. Each of the different paintings may seize the viewer with the conviction expressed by the individual artist's vision. Art opens itself to and teaches the importance of individual experience and vision, for the artistic image is not transparent as is the thermometer. Art does not fix attention on an objective situation beyond it; rather, the image itself, as a set of significant relationships perceived by an individual, becomes the object. Thus, it appears that there are some essential incongruities between the languages of art and medicine.

However, as necessary as the transcendence of direct experience is to the scientific processes of medicine, there are other aspects in the making of a diagnosis and medical practice in which direct and individual perceptual experience is essential. Later in this volume, E. A. Vastyan has chosen to use the term "humanistic skills" for this area of medicine, while John Burnside, another dialogist, has referred to "processing and judgment skills." In the employment of these skills, one of the most important components is an openness to the richness of the perceptual experience. It is crucial that attention not be prematurely focused or that the particular experience not be related immediately to some preexistent category or another experience. The quality of the experience matters to these skills and its directness and individuality are highly valued. The space in which these skills operate is an aesthetic space, which Charles Rusch has aptly described as a "state of pure attention." This seems to be the area in which the languages of the visual arts and medicine become congruent and in which art may share with medicine its expertise in this type of seeing and in the creative process.

Art works with this language of vision. Art educators such as

Gyorgy Kepes have examined the "grammar" and "syntax" of visual language—the relationships within it. Various art schools like the Bauhaus during the 1920s in Germany and the Institute of Design in Chicago have sought to explore and teach this language and to restimulate the sensory awareness of the students. This training in the language of vision is a necessary balance to the predominance of the verbal mode in other educational experiences. To see in a way limited by the verbal mode is to see in a way that no longer reflects current notions about the structure of the world and experience. The title of Dr. Hayakawa's preface is "The Revision of Vision." The very title points out how languages must change in response to the dynamism of experience. The language of vision must be revised; otherwise it will not match with a changed reality. It is important to realize that art and vision have undergone a major shift in the past century. Cultivation of a way of seeing in which emphasis is placed upon the pure phenomenal experience of vision has been a relatively recent develop-

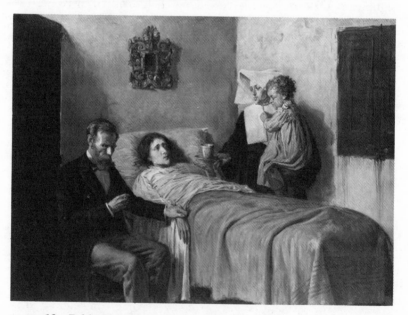

PLATE 13 Pablo Picasso, *Science and Charity*, 1897.

Courtesy Museo Picasso, Barcelona.

ment in the history of art. Only since Impressionism has art defined itself as a predominately visual language and taken steps to expurge from itself literary elements representative of more verbal modes of experience. These literary elements were products of a verbal mode of experience that became very influential in art during the Renaissance when the terms and concepts used to judge paintings were those of rhetoric.[33] With Impressionism art broke away from this " 'object'-minded," linear, and verbal paradigm and became "relation-minded," simultaneous, and more purely visual. A discussion of two works of art can be used to draw out the significance of this change and its possible relevance for medicine.

In 1896/97 Pablo Picasso painted a large, almost life-size composition entitled *Science and Charity* (plate 13). Done when he was fourteen or fifteen years old during his second year at the School of Fine Arts in Barcelona, it won an honorable mention when shown in 1897 at the National Fine Arts Exhibition in Madrid.[34] The award recognized the total conformity of the painting to the proper academic ideal of painting. It has clearly defined *historia*, a literary concept narrated by the figures and their compositional relationships. The *historia* is announced by the title. Modern science in the form of a doctor and the traditional charity of the church personified by the nun come to the aid of a sick, destitute woman. The doctor attends to her physical ills by taking her pulse, while the nun cares for her child and offers spiritual and material nourishment. Science and charity are proclaimed as forces of good in the world. All compositional elements are marshaled to focus our attention on this idea. A strong light molds each form as a clearly defined actor in the drama occupying its individual space on the stage. Vertical elements close the space to the sides, not allowing the viewer's attention to wander. Vision is controlled, the eye led by the diagonals of the bed and the doctor's spatial position to the sick woman's face about which the drama revolves. Gestures and facial expressions are presented clearly, serving to narrate the *historia*.

Picasso's painting is not based on vision, but on a literary idea. Vision and reality are controlled by this preexisting idea and forced to serve it. The parts of the drama were assembled; a beggar woman and her child were called up from the street to pose in

Picasso's studio, his father was asked to take the role of the doctor, and a young boy was outfitted in the costume of a nun.[35] Picasso creates a conventional vision and reality, a language trapped by

PLATE 14 Claude Monet,
Camille on Her Death Bed,
1897.

Courtesy Musée du Louvre, Paris.

stereotypic and outdated ideas about medicine, church, illness, space, and painting. It is evident that at this point in his career Picasso adhered to the vision of his academician father and was unaware of the Impressionist "revision of vision" that had occurred in Paris several decades earlier.

Claude Monet's painting, *Camille on Her Death Bed* (plate 14) — done in the early morning of 4 September 1897 at the time of the death of Monet's wife — has a subject that is similar to Picasso's painting, but the vision is totally different. In fact, one might say that vision is the content of the painting; there is no *historia*. The creative process and issues of Monet's painting are best described by Monet himself in a statement to Georges Clemenceau:

One day, when I was at the death-bed of a woman who had been and still was very dear to me, I caught myself, my eyes fixed on her tragic forehead, in the act of mechanically analysing the succession of appropriate colour gradation which death was imposing on her immobile face. Tones of blue, of yellow, of grey, what have you? This is the point I had reached. Certainly it was natural to wish to record the last image of a woman who was departing forever. But even before I had the idea of setting down the features to which I was so deeply attached, my organism automatically reacted to the colour stimuli, and my reflexes caught me up in spite of myself, in an unconscious operation which was the daily course of my life—just like an animal turning his mill.[36]

Monet suggests that while mourning and staring at the face of Camille his vision reacted spontaneously to the color sensations that his eyes received from her face. This was before any decision to paint a memorial recording of her image. Monet's statement registers the guilt he experienced upon becoming conscious of his automatic action of his perception. His way of seeing shocked him, and he suddenly faced the question that while this manner of vision might be a way of recording a landscape or still life, was it a proper response to the face of his dead wife? In 1866 certain conservative critics had characterized the painting shown at the Salon, *Camille (The Green Dress),* as inhuman because of its purely optical approach.[37] Confronting the meaning and importance of his wife's death, Monet suddenly seems to have doubted his own vision. He felt the need for a category. He should see something else—perhaps death in the way it had been seen in the past with symbolic allusions, a structure of meaning. However, the physical existence of the painting is evidence that, while Monet considered his doubts, he ultimately rejected them. He went ahead and realized his sensations; he made the painting.

What is radical about this vision is that it is primarily an example in painting of a "state of pure attention." In the 1860s Monet had developed in his landscapes a new way of seeing. Working directly from the motif, he tried to see purely, expurging from his mind all preconceptions about what a painting was, all of the structures and approaches found in previous painting. The painting became the physical realization of a dialogue at a specific place and moment in time between the objective reality of

the motif and the inner subjectivity of the artist. The Impression-
ist picture is a pure expression of art's fundamental base in direct
experience and individual response mentioned earlier. Unlike Pi-
casso's painting there are no preexistent categories of meaning in
Monet's picture. Meaning is something found in the process and
moment of making. Therefore, it is not that the 1866 and 1879
portraits of Camille lack humanity, but rather simply that they
cannot be situated within a previous pictorial language of what
constituted humanity. When he responded to the vibration of
color on the face of Camille, Monet was not ignoring her or his
humanity. He was, in fact, linking them. He wrote at another
time, "The motif is not just some insignificant thing for me. That
which I wish to reproduce, is that which is between the thing and
myself."[38] Obviously, a color sensation for Monet had both objec-
tive and subjective components. The way he saw and the character
of the conversion of perception into a colored mark on the canvas
were affected not only by the motif, but also by his emotional
state. The wonder of *Camille on Her Death Bed* is the tension be-
tween the objective recording of nuances of whites, greyed blues,
reds, and yellows and the network of quick slashing strokes that
set the sensations on the canvas. That dialogue between the mute
face of Camille and the eye and mind of Monet contains the
humanity of their relationship—the love they shared; the physical
and psychological pain brought into the family by this illness
which had lasted for three years; the anger that Monet must have
experienced for having to give up painting to care for Camille
and his son Jean and, of course, his subsequent guilt; and the
question of death.[39] The vortex of brushstrokes about this faint
image of Camille's face conveys a need to seize meaning from
these vibrations before they forever fade from sight. Sight—the
revelation of color and light—was for Monet the ultimate reality
available to humanity. Clemenceau recounted that Monet had the
following to say about this experience: "I am simply expending
my efforts upon a maximum of appearances in close correlation
with unknown realities. When one is on the plane of concordant
appearances one cannot be far from reality, or at least from what
we can know of it. . . . Your error is to wish to reduce the world to
your measure, whereas, by enlarging your knowledge of things,
you will find your knowledge of self enlarged."[40] The regard of

the eye for Monet does not categorize or reduce that reality, but rather maximizes it in all of its variety, and in so doing opens a perspective into the unknown reality of the self.

By concentrating his attention upon vision, Monet began to articulate its language, freed of the verbal model. This examination was carried further by the Neo-Impressionists at the end of the century through their studies of both scientific and occult theories.[41] In the early twentieth century, artists such as Wassily Kandinsky and Piet Mondrian began to explore the symbolic and vibratory language of color utilizing the ideas of Theosophy about the meaning and character of auras.[42] Several artists soon felt that they had approached a visual language "which could signify the world without depicting it, which could be meaningful without being realistic and which could contain conceptual knowledge within a framework of purely abstract forms."[43] Kasimir Malevich's *Private of the First Division* (plate 15) stands at the threshold of this abstraction. It explores the visual meaning of the archetypal symbol of the square, which replaces the illusionistic image of a face.[44] The painted and collaged forms of the picture are juxtaposed to the presence of a thermometer affixed to the surface of the canvas. Malevich seems to assert by this gesture that the quantitative scientific language of the instrument and the visual language of the painting are fundamentally different. The thermometer may register the temperature of the room in which the painting is exhibited, but this system of logic relates nothing about the other reality and language of the painting. Malevich presents the viewer with two unreconciled systems of organizing, using, and communicating sensory experience.

Medicine, on the other hand, provides a ground for reconciliation. The health care provider in making a diagnosis works with the objective information provided by the thermometer and other scientific processes of the examination procedure. The diagnosis becomes the physical realization of a dialogue at a specific place and moment in time between the objective reality of the information provided by the examination and laboratory reports and the inner subjectivity of the physician. All factors including the recognition and acknowledgment of subjective feelings must be held in attention. Most importantly, the patient must not become transparent—that is, be seen as a category of disease. The patient is

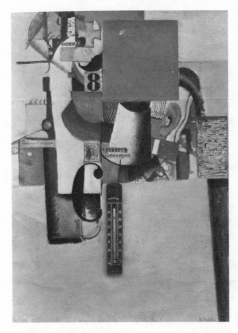

PLATE 15 Kasimir Male-vich, *Private of the First Division*, 1914.

Courtesy Collection, The Museum of Modern Art, New York.

perhaps, better understood as an image, an immediate constellation of significant patterns and forces which include a variety of types and scales: physiological, psychological, economic, and social. This image is a linking together of subject and object, of health practitioner and patient. Much that was said earlier about the relationship between Monet and the subject of his dying wife could be said of the doctor-patient relationship. Monet's statement of Clemenceau quoted earlier establishes a common ground between the artist and the health practitioner. Both "expend their efforts upon a maximum of appearances in close correlation with unknown realities." Art and visual language with their emphasis on individual experience in a state of pure attention deserve to be investigated more closely as models for attaining a goal common to art and health care—"to enlarge one's knowledge of things and thus find one's knowledge of self enlarged."

As an architect interested in medicine, I have become fascinated by ways in which individuals proficient in the visual arts could learn from those in medicine. The following article explores the relationships between architecture and medicine in four distinct areas. I begin with the identification of basic assumptions underlying both professions, and proceed to the more intricate premises of professional structure. Next I define further those characteristics common to both professions relative to certain cognitive skills. In this endeavor, I have concentrated especially on the right hemispheric skill of three-dimensional visualization. In the final sections, I emphasize relationships between both professions with regard to problem-solving activities and artistic possibilities.

7

On the Relationship of Architecture and Medicine

Charles Rusch

Explosions of both population and knowledge have resulted in a modern society which suffers from overspecialization, fragmentation, and subsequent alienation. In efforts to alleviate these very serious problems, society as a whole has descended *en masse* upon professionals in every field. In medicine the physician is viewed as someone capable of curing illness, repairing broken limbs or malfunctioning organs, and even providing therapeutic reassurance. Two of the consequences of this overreliance on the profession have been overspecialization (or fragmentation) for the physician and spiraling medical costs for the patient.

In a similar way but admittedly to a lesser extent, architecture is looked upon to cure problems of urban decay, to restore old structures while designing new ones, and to provide housing for the poor, the elderly, and the homeless. Architects in the United States are not viewed with the same esteem reserved for physicians, though in some European countries they are. Even though society may have to build as much housing in the next twenty-five years as it has in the history of civilization, architects in this country will design only about 5 percent of that housing. Indirectly, however, their designs will affect a much larger share of the market.

Professionals in the fields of education, social welfare, law, engineering, and public health have similar complaints about being overextended in light of societal pressures for change. Because of the seemingly overwhelming nature of these pressures on so many people, perhaps it would do to examine alternatives to attempts now being made to change this situation.

Adopting the structuralist position so as to look for basic structures or root assumptions may be a good beginning. For example, there is a supposition within society that the professional fields as a whole can solve society's problems. This assumption seems to be of rather recent origin in that earlier settlers, notably the Pilgrims and pioneers, had no such thoughts. In fact, the tradition in the United States of the rugged individualist indicates that overreliance upon professionals to design houses, heal bodies, educate children, compute taxes, and so forth, did not really flourish until this century.

After the turn of the century, all the professions underwent extensive transformations. While architecture as art has ancient roots, architecture for the masses is a recent phenomenon. Similarly, the origins of landscape architecture and urban planning as professions date to the late 1800s and early 1900s. The practice of medicine was dramatically transformed starting with the publication of the Flexner Report in 1910. Most of these changes were positive. With specialization each professional became more competent, had more information to draw upon, and became more effective in serving society. These were important change points which we should not reverse. Yet it seems that we are now at a point in which a similar radical alteration of assumptions is feasi-

ble. For example, to solve the numbers problems connected with mass housing, architects are beginning to look towards the possibility of the users being trained to design and care for their own environments. The architect's role would then shift to something more like that of facilitator, teacher, or consultant to user groups charged with design.[45] Parallel in medicine is the movement toward self-care. One can also find parallels in law (self-care legal books), education (the deschooling of society), social welfare, public health, and other professions as well.

More specifically, there may be fundamental assumptions in each profession that if revealed would offer new options for seemingly intractable problems. Three such assumptions in architecture may be examined:

Architects design buildings. Before addressing this assumption directly perhaps I should address a similar assumption first: *architects build buildings.* Very few architects actually build buildings. Of those who are involved in the design of buildings, some supervise the construction of buildings which they or others in their firm designed. However, such supervision only means periodically monitoring the work of contractors to see that the work is being done properly, or occasionally solving problems that come up in the field. Most architects do not build; rather they design and specify their buildings on paper for others to build.

Those architects who are active in design quite often also design furniture, dinnerware, plazas, malls, lighting schemes, and so forth. Of those trained in architecture many practice design only briefly and then take on roles such as consultants, teachers, researchers, businessmen, real estate developers, and salespersons. Some go on to become environmental critics, theorists, and historians. Only half of the students trained as architects actually become designers of buildings (a statement I have also heard made about the training and practice of law). That does not mean that the training is wasted. Design is an action-oriented attitude or state of mind about life. Training in design is training in the attitude that life's conditions can be altered. It is a form of training urgently needed at the present time. As long as architects and others see themselves primarily as builders of buildings, they will be denied the far more influential role of institutional and environmental problem solving. Society currently is changing so rap-

idly that people need to reexamine institutions and reevaluate relationships between these institutions and their environmental settings. Architects could play a far more influential role in this regard than they presently play.

Architects are responsible for the quality of the environment. (Put more crassly, architects control the built environment). I believe this assumption is more widely held within the profession than outside it and is perhaps more appropriate for the Scandinavian countries than for the United States. As mentioned earlier, architects are directly involved in a mere 5 percent of the buildings constructed in America. Even among these projects, the quality of the final product often is controlled more by early financial and political decisions than by architectural design. By the time an architect is brought into a project there is often little that can be done but to ameliorate that which is to be overbuilt, oversold, and overpopulated. Even after the design is completed, its quality is often further compromised by budget cuts or political decisions. If architects faced up to these facts, they could possibly alter decisions wherein the quality of the environment actually is set. I remember a student research project in which all the *irrational* choices in the decision-making history of a project were ferreted out and studied. This method seems to be the only way to discover hidden factors affecting environmental quality.

Architects design environments which improve the lives of people living in them. Another form of this assumption is that people are happier and more productive in well-designed environments than in makeshift or adapted environments. This is one of the most difficult assumptions for architects to give up because it seems to attack their *raison d'être.* It is true that in overcoming an inadequate environment, resourceful people can transcend even their own expectations of what they thought possible. I have personally seen numerous theater groups do enormously creative work in converted makeshift spaces. Some of these, elevated to plush theater buildings, have become curiously second rate. Environments do not improve people's lives; people improve their own lives. A well-designed environment can at best make that process easier. We need to learn ways to design environments *with* people rather than *for* them, so that the process of design itself can become the medium through which people improve their lives.

Now it seems appropriate to modify the above assumptions so as to examine them in the context of medicine.

Doctors cure patients. However pervasive this assumption may be within society, it seems false. *Patients cure themselves* or *bodies heal themselves* might be more accurate. Doctors diagnose illness and prescribe treatment. The cure remains up to the patients. Even in the most mechanical operation in which a surgeon is replacing a malfunctioning part, such as putting a graft in the aorta, the patient or the body or both can reject the graft. Therefore, the most reasonable approach seems to be that of a cooperative team, a collusion between doctor, patient, and body. (I do not mean to imply that the body is different from the patient, but sometimes it seems to have a mind of its own.) The role of the doctor is essential in this situation. He must work to set an attitude of understanding and acceptance within the patient, a belief that a cure is both possible and desirable. Patients are not objects to be repaired like automobiles. It is just such thinking which has led to efforts to "humanize" medicine. I think if I were a physician I might even try talking to a comatose patient on the off-chance that he could hear me.

As long as doctors see themselves (and allow others to see them) as being responsible for curing patients, the demand for medical services will continue to increase, and patients will be denied the satisfaction of having cured themselves. The bridge to self-care and the solution of the numbers/demand problem is obvious.

Disease is the result of an overwhelming attack of outside "micro-agents," or antigens. Here again a contrary view seems to be emerging. Perhaps the antigens are present in and around the body most of the time but are held in check by the immune system. The onset of disease could be explained as a lowering of defenses to achieve psychological ends (attention, care, compassion, rest, even death). This view actually receives some attention and support from medical research.[46] Perhaps patients not only cure themselves, but also create their illnesses.

Medicine is about the treatment of disease. Medicine is also about the *prevention* of disease and the promotion of health, as everyone in the field realizes. Yet preventative medicine limps along, the underfed cripple in a well-nourished home. Admittedly, enormous strides have been made in the area of public health. Smallpox,

polio, tuberculosis, tetanus, cholera, and many other diseases are now under control, at least in the Western world. On this scale, the prevention of disease has been extremely effective. Nevertheless, I am not certain individual members of society know much more about the prevention of disease in their bodies than before these discoveries were made. People tend to know a few rules about cleanliness, the spread of germs, and perhaps enough to keep innoculations up to date, but little more. Even less is known about the promotion of personal health. An enormous amount of knowledge has been amassed through medical research concerning the relationship of good nutrition to health. Yet little of this knowledge seems to have reached the average citizen, at least if the popularity of fast food, junk food, and processed food is any indicator. Nutrition finally is being considered a viable subject for public school curricula, although junk food is often all that is available at "nutrition breaks" (recess). Whether the study of nutrition is given sufficient emphasis in medical schools has also come into question.

I do not mean to imply, however, that the medical profession is somehow at fault on these social issues. Mass processing of food in the United States arises from a very complex set of forces. Although medicine cannot be held responsible, it could perhaps lead the way toward a healthier society by shifting emphasis away from treatment of disease and toward teaching people to be responsible for their own health.

Each of these challenged assumptions are offered as examples of ways that slight shifts in attitude or outlook might help alleviate an otherwise intractable problem. Every discipline, every profession is built upon similar assumptions. "Artists uplift and inspire, humanists humanize, doctors heal, lawyers create and argue the law, architects design buildings."[47] Structuralism teaches that it is these fundamental assumptions which lie at the base of our culture. Problem-solving activities teach that persistent problems which seem to grow worse with treatment often need to be studied at a deeper level.

A pattern begins to emerge; self-care in medicine and law, user design in architecture, neoconservation in the politics of the Left. The answer to the numbers problem seems to be to learn how to take care of ourselves. With such a pattern, rugged individualism

returns, but in the service of society as well as self. The process is facilitated by a battery of knowledgeable professionals and extraordinary machines. It might not seem much different on the surface, but the difference in education is enormous. If architectural schools are to train professionals to teach the public to design and maintain their own environments, then that is a far different educational task than the one now performed in training professionals to do it for them. Perhaps similar implications could be drawn concerning medical education. Looking at the present condition of urban decay and city budgets, or at the spiraling demands and costs of medical care, it becomes evident that there are not many years left to make the changeover.

As the above discussion indicates, I think both architecture and medicine can be seen as problem-solving disciplines. In fact, the term probably fits medicine better than architecture. In architecture, problems are never "solved"; a more accurate phrase might be "situation changing" with presumably an improved condition between changes.[48] In medicine, sometimes problems really are solved in that the disease or illness is cured and full health is restored. Both disciplines have been quite self-conscious about their respective problem-solving techniques, although reticent to admit it. In medicine after the illness is "diagnosed," the physician proceeds to "recommended treatment." In architecture after the problem is broken down into its component parts and "analyzed," the architect proceeds to the next step—"synthesis." This process usually involves generating a number of alternative solutions (thinking "divergently"), and then selecting one on the basis of some predetermined selection criteria (thinking "convergently").

In any case, the cognitive skills required of medicine and architecture may be similar. Both require a combination of spatial visualization skills (imagining the tumor in a particular place in the body or the fireplace in a particular place in the living room) and reasoning or logical analysis. While it seems to me that surgery is the medical specialty which is cognitively closest to architecture, I think the ability to visualize pathological and healthy conditions, as well as processes or mechanisms of recovery (such as white blood cell activity) would also be useful in other specialties. Research on lateral specialization of the brain indicates that spatial ability is a function of the right hemisphere of the brain and

reasoning a function of the left.[49] Unlike many other disciplines which are strongly dominant in preference for one hemisphere or the other, architecture and perhaps medicine require a balance of both. Such a balanced approach to problems of this nature is sometimes called "visual thinking."[50] It might be useful to explore this cognitive area of overlap between medicine and architecture in some detail and look for implications in the training of both doctors and architects.

Visual thinking is actually something of a misnomer. "Imaginal thinking" would be closer. Imagery involves experiencing mentally in any or all of the sense dimensions. Since sight is our dominant sense, the dominant form of imagery is visual. However, there is also gustatory imagery (imagine the taste of ketchup); olfactory imagery (imagine the smell of a rose); auditory imagery (imagine the roar of the waves); and tactile imagery (which includes pain, pressure, and temperature).

Imagery is different from perception in that there is no object present in imagery, thus no sensation or stimulation at the nerve endings. Imagery is created from memories. The content of imagery is drawn from the content of previous perceptual experience stored in memory—thus, the properties and qualities of earlier percepts. The content of a visual image has to do with the shape, form, color, texture, and material qualities of the objects which make it up. How realistic and detailed the image is determines the degree of *clarity* with which it is held.

Images also differ in terms of our ability to *control* them. Can we make the image stay present and do the things on command we want it to do—such as rotating, transforming, or moving? These operations are drawn from the sensory motor system (as opposed to the perceptual system) and from memories of countless actions taken over a lifetime. Clarity and control, then, are the two principal dimensions of imagery and are related respectively to the perceptual system and the sensory motor or muscle system.[51]

Images can also be abstract (that is, fuzzy and ill-defined) or concrete (that is, corresponding to reality). Another term for "concrete" is "figural." This is a different dimension from clarity. If I ask you to imagine an apple, it will be more or less clear; you may see the apple as red, yellow, or green, with flecks, bruises,

nicks, and changes of color from top to bottom, or without any of these specific features. If I ask you to imagine apples in general, a more abstract image might appear, the generic invariance of all apples,[52] also without specific features, not because of its lack of clarity, but because of its abstractness. While most concrete images are also relatively clear, an image could be both concrete and unclear, like a picture out of focus, yet none the less real. In contrast, the abstract apple is like a drawing representing all apples.

Abstract imagery seems to be necessary more for the architect than for the doctor. At the beginning of a problem an architect does not know what a design looks like yet because it has not been designed. All that exists is perhaps some abstract notion of the relative size of spaces required and how they might relate to one another. Shape is represented as blobs drawn on paper or pieces of cardboard cut to the approximate relative size. Gradually, as the architect begins to design, the form emerges until the design work is finished. It is at this point that the architect quite literally "sees" (and feels) the building as it will look after construction. At this point, the building is seen not only as a series of spaces and forms, but as colors, textures, materials, and light qualities which will vary with different times of the day, and different days of the year.

The word, "visual," then, in the phrase "visual thinking" applies to all forms of imagery; the word "thinking" applies to the process of directed logical reasoning by which these images are ordered and used to solve problems. In diagnosis, a doctor might use perception to read the patient's body position, skin tone, color, and emotional state; oral questioning to determine the symptoms and their history; laboratory analysis for indicators unavailable to perception; and visual thinking to imagine the malfunction in some body system which could be causing the patterned responses given above. The doctor might get an immediate sense of the disorder (right brain processing) and then verify it through testing and consultation (left brain processing), or the order might be reversed. A physician who imagines a particular disease attacking some organ or body system and checks the consequences of such an attack against information at hand is using visual thinking procedures. Similarly, a surgeon must learn exactly how the body

is constructed and then determine precisely where the malfunction is occurring before cutting in to repair it. If the above medical conjectures are correct, in both cases, imagery and reasoning are required to work together in solving the problem.

A few words about the education or training of architects—and perhaps doctors also—from the standpoint of cognitive ability seem in order. Architects have to be trained to see in a holistic manner. This training appears to be essential for doctors as well. An architect or physician taking the holistic approach should not miss much when looking at an environment or a patient. Without being a doctor, I would imagine that much can be learned from the way patients walk, or sit, hold their bodies, the way they breathe, the look in their eyes, the color of their skin. Artists are among the few groups in society who are *trained* to see; for most of us it is assumed we know how to do something so basic. Nothing could be further from the truth. In fact we are trained to conceptualize and then see the concept.[53] A young child is trained to retain the information that flat surfaces with four legs are called "tables." Once the concept has been learned, a person no longer has to look at the table. A cursory glance will do since all that is "seen" is the concept anyway. Architects are trained to *see* tables again, as well as to recognize more illusive concepts like "space" and "light quality."

It seems natural, then, to assume that doctors should be trained to see their patients, not their knowledge of a particular disease the patients might have. It is a well-known fact that the way the perceptual process works, we see what we want to see. Seeing diseases rather than patients could lead to misdiagnosis. I think that good diagnostic procedure (and here I am really out on an unfamiliar limb) would include at least the following stages: (a) total uncertainty, not knowing, without preconception or prejudgment; (b) total attention, "seeing" the patient completely; (c) total knowledge, comparing what has been seen with what is known, open exploration of possibilities; (d) scientific verification; (e) certainty leading to action.

I admit unfamiliarity with how doctors are trained in diagnostic skills. Dr. Cody, one of the dialogue members, states that medical students are trained in "differential diagnosis in which judgment is held in suspension while all possibilities are considered and

checked out." Dr. Burnside, another member, says that "medical schools do not train the student to tolerate ambiguity and uncertainty." Perhaps both are correct. Whatever the case, I think it is important for medical schools to train students not only to tolerate ambiguity and uncertainty but to be comfortable with these aspects and to see them as necessary diagnostic steps. Furthermore, it seems essential that each case start from a clean slate, a condition of not knowing. Also useful for medical students would be training them to attend or see without judgment, as art students are trained to see. Without these first two steps, the last two might be unnecessarily difficult and time-consuming. In this diagnostic schema, the imagery referred to is part of the knowledge step; "visual thinking" would be covered by steps three and four. Images as a form of concept can be equally misleading. For example, instead of seeing the patient's present condition, the doctor might respond to an image of the patient based upon past associations or the patient's medical history. Even a new patient can be put in such a category and not fully "seen."

The education of doctors and architects, then, most obviously overlaps in two areas: the education of attention, and problem-solving strategies including visual thinking skills.

Last of all, architecture and medicine can both be seen as arts. Architecture as art is clearly established although it has its scientific side. Buildings have to stand up, the needs of user groups must be assessed and the information evaluated according to social-scientific principles. I am not sure whether medicine as an art is often discussed, or if it is, whether it is ever practiced as an art form. Surely there are some doctors who look at their practice this way, although most probably do not.

In my opinion, the essence of the practice of some activity as an art form is the presence of aesthetic experience in the act. By aesthetic experience I mean those moments of pure perception in which there is no sense of self or separateness, no division at all, just complete attention to the act without reflection or the conscious marshaling of knowledge. One just acts. I shall call this state of acting primary experience, as opposed to secondary experience, wherein an individual experiences action indirectly through a system of symbols learned since birth (or before). To understand more fully aesthetic (or primary) experience and consequently ar-

chitecture and medicine as art forms, perhaps it might be helpful to explore briefly how primary and secondary streams of experience develop side by side in the individual.

Child development can be considered a process of achieving greater and greater distance between the external form of experience and its inner meaning.[54] At birth a child's experience must be almost unitary, although perhaps chaotic and meaningless.

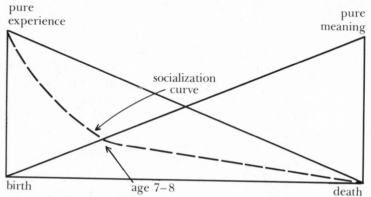

FIGURE 1 **Life seen as a transition from experience to meaning with socialization as a suppressor of pure experience.**

Without meaning there can be no differentiation between sensations—thus, experience must be unitary. If life were a continuous spectrum one could see a gradual passage from total experience without meaning to meaning without experience. At birth there is the unitary (blissful?) state of pure experience, and at death there is the unitary (blissful?) state of pure meaning. Life could be seen as a passage between one state of bliss to another (or perhaps the same one with a different label). In between occurs a series of acts which give meaning to the experience of life.

The problem is that the act of giving meaning involves the creation of symbols which then stand for the experience and the inner meaning attributed to it. In order to create symbols a division must be made between the symbol and the experience. Thus, the symbolic act is the origin of the separation of secondary and primary experience. Furthermore, as a vast symbolic structure begins to develop, an individual begins to identify with that structure (that is, secondary experience), and to stop identifying with

primary experience or with the initial sense of being. In more colloquial terms, we *become* our concepts, our meaning system, our knowledge. At the approximate age of seven children enter the realm of the abstract. They have learned how to create and understand meaning removed entirely from experience, and from then on they deal with life indirectly through the manipulation of symbols. As I stated earlier, individuals no longer "completely see"; rather they see their concepts instead, how they believe things should look, as opposed to how things actually are. In this way they "become" their mind and knowledge systems, and consequently no longer have access to that primary experience they "knew" at birth.

In every society, however, there are those that somehow keep in touch with primary experience. In some societies, it is the shamans, or witch doctors; in others, the priests; in still others, the artists and poets. It becomes the task of those few to remind the rest of us of our origins, or primary, unitary experiences. It is not that these individuals do not develop the same symbol systems as the rest of us; they do, and they communicate to us with the help of those symbols. It is that they do not identify with that knowledge; they know experience which lies beneath it.

What all this has to do with architecture and medicine is that primary experience is available to all of us, not just the few. Life does not need to be experienced through the filter system of the cognitive mind; there is direct perception as well. These moments of pure perception are perhaps reached by everyone occasionally, by most artists during periods of inspiration, during all great moments of sports, music, dance, theater, religion, design. Those are the moments of pure experience, sometimes called "aesthetic experience" when knowledge (or meaning) is either unimportant or operating on "automatic" outside of consciousness. Life becomes awareness, and at the same time, because one identifies with awareness rather than "persona," there is a loss of the sense of self. There is no ego, no image, no "personality" to get in the way, to get between one's sense of being and the experience of the moment. Good architects design in that cognitive space. Could it be that good surgeons operate in it, that diagnosticians who completely see their patients are looking from that space without knowledge (only for this moment, because they will need the

knowledge later), without emotion (yet with great compassion), without images of the patients' history or problems? These are artistic moments, aesthetic moments, and indeed moments of extraordinary value.

The issue of emotion perhaps needs some clarification. I believe these moments are without emotion. However, as soon as the moment or action is complete, the individual is flooded with emotion, usually joy, elation, wonder. Pole-vaulters go over the bar without emotion. On the ground after breaking records they are seemingly *all* emotion. Those moments *appear* to be highly emotional, but I believe their essence is not, in fact, cannot be emotional.

The educational questions remain. Can one learn to achieve that state of aesthetic experience? Can it be taught? Is it really safe to practice a profession in a state of mind so seemingly outside of knowledge, or does the experience belie the danger of the act? To take the last question first, I cannot see how acting in such a state of awareness could be anything but considerably safer than acting separated from one's primary experience by preconceptions and images of the past. As pointed out earlier, diagnosis would seem to be easier and more accurate in a state of pure attention. Informal conversations I have had with doctors who know what I mean have validated this point. Conversations with architects about extraordinary work reveal a similar state of heightened attention. As for performance, particularly under emergency or stressful conditions, what better testimony can there be than from athletes who under conditions equal to the emergency room (sometimes even life and death conditions, such as racing Formula One cars through European towns at 150 miles per hour), perform with remarkable skill the most demanding and delicate acts while playing "out of their minds."[55] It is not that years of acquired knowledge is not there. It is rather that the individual, while acting in a world of knowledge, is "coming from experience" rather than "coming from knowledge." In other words, any thinking happening at the moment is completely subservient to experience. Knowledge, in those moments, serves experience.

Perhaps the phrase, "out of their minds" while intended to be both provocative and descriptive in sports is unnecessarily strong for use either with architecture or medicine. "Beyond their minds"

or "beyond knowledge" might be more appropriate. No surgeon, having performed a truly remarkable operation is going to brag about operating out of his mind. I am told by Dr. Cody "that most surgeons, before they operate, go to great lengths to determine beforehand what they will find. They do not wish to encounter any surprises. Ideally, they know beforehand exactly what they will encounter and have already plotted their strategies for correcting the difficulty." I have read that racing car drivers go through the same preparation: minutely inspecting the course, driving it at different speeds, imagining everything that might happen at every turn and straightaway. Once the race begins, however, all that knowledge is held aside. The great drivers enter another realm of consciousness wherein their attention is so great that driving 180 miles an hour is like driving 60 miles an hour under normal conditions.

Such extensive preparation might lead one to conclude that these individuals can perform automatically like a machine because of both the race preparations and years of over-learning. That is not what I mean by complete attention or aesthetic experience. Performing mechanically is what I call a reduced state of consciousness. I am speaking of a heightened state, one in which there remains the possibility of reentering primary experience and at the same time performing a highly technical and complex action. There is no way that a surgeon or race driver can anticipate every future event; a broken bolt in the car or a sudden hemorrhaging on the operating table might call for a remarkable response. Architecture has no comparable moments of emergency that I know of, although the sleepless days and nights meeting a deadline can certainly be full of stress and call for extraordinary performance.

I am uncertain about the best way to teach aesthetic experience as the reentry of primary experience. I know we can teach people to perceive more fully.[56] I know we can teach people to relax.[57] Both of these things paradoxically seem to be part of this experience. I know we can teach people to still the chatter of their minds, which is also part, but there seems no way to guarantee the unifying experience. As a teacher, I know there are those moments when there is no distance between myself and the students,

myself and the material. In fact, there is no experience of self at all. But the very next class can be otherwise. Athletes cannot predict their peak performance, nor can architects, doctors, or teachers. The best one can do is set the context for the extraordinary, and then be ready and willing to experience completely whatever happens.

Although much has been stated about the visual arts in general terms, commentary about the ways in which a particular work of art impinges on the mind and feelings of an individual has been minimal. The following essay is an attempt to depict the intimate effects of a single painting on a single viewer. It is not an exhaustive report of all his responses, conscious or unconscious. Nor is it in any way meant to include all the possible responses of other human beings —for these would be close to infinite. Rather, it simply tells of one physician's love affair with a beautiful nineteenth-century symbolic painting.

8

A Grain of Sand

John Cody

The "visual arts," taken *en masse* as a category, is to my mind ungraspable and nearly imponderable. Because included in the term is such an enormous diversity of forms, so near an infinity of examples, one is hard pressed even to abstract the essential universal features. And, that tough problem being solved, where is one to begin to consider the applicability of something so vast, diverse, and subtle to the domain of medicine, itself an ever changing realm of tremendous complexity? To mull the question in an effort to stake out its dimensions is to be quickly overwhelmed. Yet all the members of the dialogue group had a strong intuition that the visual arts, broadly defined, did indeed have

something enlarging and enlightening and humanizing to say to physicians. But how to get at it?

Perhaps we were starting at the wrong end of things; perhaps our telescopic view was the problem. What was needed, maybe, was a concrete, manageable example. The molecule's anatomy comprises clearly and in miniature much of the grand blur of nebulae, but it is a lot easier than nebulae to handle and examine. Might not an examination, therefore, of the impact of one artwork on one medical student reflect in its small way something of what a universe of such encounters might be expected to accomplish in its big and—one supposes—important way? To me it seemed worth a try, and this essay is the modest result of that feeling. At its conclusion,

PLATE 16 William Blake,
Elohim Creating Adam, **1795.**
Courtesy The Tate Gallery, London.

but not before, I may hazard a nebulous generalization or two: but first let me consider the issue in microcosm.

The medical student—alas, for modesty and objectivity—is, or rather, was myself, and the artwork, a watercolor from the early nineteenth century. I first saw this masterpiece in a book entitled *Blake*,[58] which has an introduction by the famous Blake scholar, Geoffrey Keynes (a physician). The colors were muddy and mottled, the tipped-in reproduction small—only 6.5 × 8 inches (compared with the original in the Tate Gallery, which measures 17.75 × 21 inches). I was then a first-year medical student with a cranium full of anatomy and biochemistry and a nervous system full of anxiety. My professors in all probability would have thought it a reckless time to be riffling through an art book.

When my eyes lighted on the sublime picture something equivalent to the last inspiring, worshipful chords of *Parsifal* seemed to burst resplendent in my mind. I was seized at once with a desire to have it up on my wall where I could gaze at it constantly and see it everyday. But the print was so ridiculously small I would have had to get within two feet of the wall just to make it out. My usual source of reproductions was Marboro's, and I knew this was one painting that had never been among their offerings. Nor had I seen it advertized in the catalogues of other print manufacturers. (To this day—twenty-one years later—there has yet to appear, as far as I am aware, a worthy reproduction of this most reverberant of all Blake designs). So I at once decided to make my own copy. This was on a Friday night.

I first carefully outlined in pencil every detail of the picture on an overlay of tracing paper. Then I imposed on that a grid of horizontal and vertical lines, thereby dividing up the traced outline into a multitude of tiny rectangles. Next I took a piece of watercolor paper slightly larger than the 17.75 × 21 inches of Blake's original and divided that up similarly into rectangles exactly proportional to those on the tracing. Painstakingly, I transferred the contents of each little box to the equivalent box of the larger grid. In this way I ended up with an accurate linear copy of the shapes of Blake's picture in the exact size of his original drawing. Then, after gently erasing the lightly penciled scaffolding of rectangles, I was ready for brush and watercolor. I had rarely worked with such devotion and care. There was nothing creative

in what I was doing; of this I was perfectly and acceptingly aware. To an observer it would have appeared, justifiably so, that I was making a slavish copy. But a slave does what he does against his will and because external force compels him. Looking back on it now my "slavishness" seems to me entirely an act of voluntary homage.

As I have said, the colors in the print were blotchy, as though the underlying paper had mildewed. Having once seen several authentic Blakes at the Morgan Library in New York, and noticing how splendid their coloring was, I reasoned that in the original the colors were doubtless clearer, richer, and more glowing than in my print. So I decided to raise the colors uniformly a degree or two in brilliance, leave out the more uncomely blotches (I sensed that some of the mottling was indeed Blake's own doing, these variations being to his watercolors what vibrato is to Casal's cello), and eliminate throughout all tinges of muddiness. I worked all weekend and by three or four o'clock on Monday morning my facsimile was finished. I was satisfied. It looked considerably better than the print, and I was certain it must be very like its prototype in London. I framed it and ever since, wherever I have lived, it has hung on my living room wall to delight me everyday. I have never grown tired of it but have long since recovered from my astonishment that visitors almost never notice it.

Later that week the biochemistry department gave a test over the material that my classmates had spent the weekend memorizing. I recall having flunked one or two biochemistry tests and this may have been one of them, although I cannot remember for sure. Anyway, it covered the breakdown of fats into triglycerides, a matter about which today I blush to say I know little. But I do not know much about the tremendously essential Krebs cycle either, and I know I was not painting that weekend. (I hope none of my patients read this.)

The painting is entitled *Elohim Creating Adam;* though itself wholly ineffable, it *is* possible to tell in words something of all I saw—and still see—in it.

What first struck up the inner chords was a powerful impression deriving almost equally from each component of the painting's dual nature, for it is both a design and an illustration, an organiza-

tion of visual forms and an exposition of a philosophical idea. The design and color sound the fundamentals and evoke in one the first sharp intake of breath; the idea supplies the over- and undertones which seem to echo into infinity. Together, in their perfect harmony, they are a miracle of richness and integration.

The background is a half disc, actually a mighty sun of orange and ochre burnished with vermilion. Its lower hemisphere is obscured by a portion of our own planet consisting here of a bit of earth covered with low, green vegetation and lapped by an edge of Prussian-blue ocean with a fringe of white foam. Between the lichen-like vegetation and the sea is a strip of sienna-colored soil. Sun and earth are in turn set against a dynamic sky. Beams of strange reddish violet—surely Dickinson's "harrowing Iodine"—fan out from the sun's perimeter against a darker sky of a cold blue akin to the ocean's. Here and there blackish horizontal streaks—scudding, scattered clouds—obscure the expanding beams, and overall there rolls a huge, dark, convoluted thunderhead whose edges are touched with golden reflections from the sun.

The powerful, muscular body of God, clothed in a flowing, clinging robe, is depicted horizontally against the sun's face. The great figure partly eclipses that flaming disc and extends well beyond its diameter on both sides. An unfamiliar image of Deity it surely is, more like some colossal angel with massive eagle's wings, plumes sculpted and wrought of heavy gold, and mid-ribs, with their vermilion tint, seemingly infused with blood. As God hovers less than arm's length above the earth his chest seems almost to touch that of the naked, supine man (Adam) who lies under him. Adam's head, hands, and feet (which resemble hooves) seem merged into the earth; his arms are outstretched so that from the point of view of God he can wear only the aspect of one crucified.

Although Blake was much influenced by Michelangelo there is a striking difference in the way the two artists portray the act of creation itself. In the Sistine Chapel, Adam already exists in full physical perfection but in a passive, almost inert, state—a body without spiritual life. His limp arm, resting on his knee, is the lightning rod to the fiery bolt God is about to deliver from his own powerful, vital, outreaching arm. This God, with his support-

ing flock of confused and terrified angels, resembles a thunder-cloud that discharges its head of electricity without effort when it encounters an oppositely charged pole.

For Blake's God, who is likewise an elderly, white haired man, creation involves tedious, agonizing labor. Man's body must be built up from scratch, bit by bit, stroke by stroke, out of the soil of earth, the way a sculptor molds his figures, a pinch of clay at a time. His left arm outstretched, God clutches at the ground, dig-ging at the unyielding soil with his fingers; simultaneously, with his right hand, he presses the last clod into the slowly augmenting mass that will be Adam's skull. And all the while that colossal body maintains itself in the air, as a hummingbird does, through the exertion of rushing, straining wings—those tremendous, weighty, brazen wings designed, obviously, not for hovering near earth but for soaring in infinity.

In Michelangelo's fresco, from humanity's first moment, evil coexists with good. God is shown with one arm around Eve, who does not allow her body to merge and flow into the general for-ward movement that binds together God and his angels. Instead, she holds stiffly back, resists the rhythmic momentum of the others, and gazes with a look of libidinous fascination at the vo-luptuous nudity of the first man.

Blake's conception shares with his predecessor's the notion of evil's early arrival but, unlike the homosexual Michelangelo, the congenially-wedded Blake was unwilling to incriminate the hu-man female. Instead, he portrays evil (in lurid shades of alizarin) as a great, loathsome snake textured rather like an earthworm. The snake, whose head appears to be hidden under Adam's but-tocks, has thrown five tight coils around the man's legs from thigh to foot as though to keep him immobilized much as the anaconda secures its prey before swallowing it.

These, then, comprise the images and polarities in Blake's painting: God-Man, Good-Evil, Light-Dark, Heaven-Earth, and Fire-Water, plus Sun, Sky, Sea, Cloud, Vegetation, and Earth. Except for Feminity not one of the primal forces is lacking, and all are woven into a design of majestic clarity, simplicity, integrity, and strength. Blake in this picture, as Keynes says, "has attempted the impossible—and succeeded."

But on first confronting *Elohim Creating Adam* one requires at least a minute or two to recognize all these diverse elements of subject matter. Rather, what initially arrests the eye are the picture's decorative, coloristic, and linear features, plus its dramatic pattern of lights and darks. One feels at once its great, overpowering energy. The sunburst, with its rays leaping out in all directions, seems a veritable explosion. And this impression of infinite expansion is augmented by a series of arcs building up from the breaking surf to the dome of the sun. The lower arcs, beginning with the sea's edge, the band of soil, the mound of lichen, and Adam's body and arm, curve ever higher until they culminate in that fiery semicircle. Then, as though to contain and impact all this centrifugal violence, are the three oppositely curving arcs formed by the bellies of the lowering thunderhead at the top. Thus, the enormous dilation is checked and a tension created between what one feels as opposing forces. Flowing freely between these forces are the linear arabesques of the robe of God whose graceful figure echoes both sets of arcs and, as it were, attempts to reconcile them: wings, legs, and arms share the sun's rising curve while chest and abdomen press down in perfect parallel to the overhead cloud rim. The basically horizontal thrust of God's body, plus the scattered horizontals of the dark, stabbing cloud fragments, introduce elements of right-left movement, while his flaring hair, the pale beard flattened against his torso, and the robe pressed to his body and streaming out behind him paint a powerful invisible wind blowing sideways across the picture into which the Deity faces and against which he struggles to maintain himself. Such are the linear elements which contribute largely to the picture's immediate effect.

The color scheme is equally dynamic and arresting and, like every dimension of this encompassing watercolor, includes all possible polarities. The vegetation's green is opposed to the snake's crimson; the sea's blue, to the vermilion flames on the solar face; that face's ground of ochraceous yellow, to the violet of its radiations. Such an assemblage of complementary pairs would certainly have been garish had they not been nuanced and adjusted to each other with perfect delicacy. But Blake did so adjust and harmonize them, and one's overall impression is not of a cacophony of clash-

ing hues but of a chromatic ensemble of great opulence. Together with the linear qualities it is part of the work's initial impact, stunning one even before the subject itself begins to penetrate.

The deployment of lights and darks constitutes the third contribution to the painting's immediate power. Again the range is total, from plangent deeps to singing incandescence. The blackest shadows fall on the coils of evil, though there are clouds that approach this degree of darkness, and from the phosphorescent foam of the sea up through the body of Adam there is an intensification of light that climaxes not with the sun's brilliant surface, but with the face and hair of God which are brighter than the sun and which form the design's focal point. One's eye is imperiously drawn to this superior sunburst which outshines and dominates everything else in the painting.

These three levels of formal organization, the linear, chromatic and tonal, all masterfully integrated, *contain* the furious energy and bind the whole together in a cosmos at once kinetic and stable. Though slow and sequential to describe and read about, all this may actually be taken in at a glance. For it is the glory of painting that it reveals itself all at once—bang!; it is the most exhibitionistic of the arts, always presenting itself in full frontal innocence, instead of coyly disclosing itself a little at a time as poetry and music do. Even sculpture and architecture require one to circumnavigate them over time; only in this way can one gradually build up in the mind their complete image, which is inaccessible all at once to the senses.

The *symbolic* content of painting, however, is another story. It provokes the process of thinking, an activity that if not positively unnatural in most of us, is at least ungrateul and time-consuming. But this consequence must be faced, and here is where I may get into hot water.

In order to survey what an art encounter can do to, or for, a budding physician (or anyone else), it is necessary to consider more than what directly impinges on viewers as they behold a painting. As important is the chain of inferences and associations that this beholding sets off in the viewers' heads, as well as their emotional responses to these inferences. For it is these responses, and not the fact that their retinas have been briefly tickled, that bind the experience to them as a significant aspect of their lives and which may

even modify them as persons. Therefore, I want to return again to the visual forms and primal symbols of *Elohim Creating Adam* to share with you something of what happens when my quirky individuality grapples with the spacious and universal images this particular painting by Blake presents for contemplation.

Let me begin with the face of God, which attracts so much attention because of its luminosity. What expression might you imagine on *your* God's face as he called forth the first creature made after his own likeness? A look of torment, sorrow, exhaustion, preoccupation? Probably not, but that is approximately what Blake has unmistakably written into the visage of his creating Deity. The brow is deeply furrowed, the anguished eyes gaze blindly into the void ahead instead of at the work at hand—the finishing up of Adam's head. The mouth is open: the exertion is so immense that God is gasping! Moreover, he faces into a gale so violent that it flattens his lustrous hair against his head and makes it stream out in two-dimensional flamelike points. His long beard likewise is plastered tightly by the wind to his chest, the latter heaving, it would seem, in his effort and desperation . . . or perhaps he is simply sobbing.

Why does Blake show the Creator in such extremity? Perhaps the body provides a clue. Though God is both ancient and winged, there is nothing frail, airy, or buoyant in his solid, heavy build. The deltoids especially are greatly developed, as would be necessary to beat those enormous wings. The arms too are powerful, as are thigh and calf. Indeed, it is a massively weighty body that the wings must keep aloft. And those shoulders that power the wings must at the same time power the arms, busy at their work of putting Adam together bit by painful bit.

For such a task as God is trying to accomplish he is obviously working in an impossible position and in an inhospitable spot. Moreover, the weather is atrocious and he is building with the most inexpensive and recalcitrant materials. Is he perhaps attempting something that is unnatural to him, unnatural even to the universe? Certainly, neither he nor it seems built for the purpose. And I here grow so irreverent as to think of a wisecrack of that blasphemer, Oscar Wilde. He said that God, throughout most of the Creation, more than did Himself proud, but when it came to Man He "somewhat overestimated His ability."

Wisecracks aside, it is impossible to inspect that radiant, suffering face and not be moved by it, nor filled with sympathy for a God who is doing his best but who knows full well from the beginning that his best is not going to achieve the benign ends he has in mind. Blake, then, apprehends God—at least in this picture—as very much in the image of Man. His God is not omnipotent and ensconced serenely above the world. Rather he is like a frightened parent who realizes that, no matter what he does, he will be unable to shield his child from the evils of existence.

I hasten to interject here that my absorption in this picture was not conventionally "religious." That the painting moved me to pity for God is no indication whatever that I believed literally in the existence of that symbolic figure. On the contrary, long before the beginning of my acquaintance with Blake's watercolor I had reached that irrevocable point in my evolving view of the world where I no longer accepted the God of the churches, nor even the "first cause uncaused" of the theologians. The whole idea of a loving, paternal presence of almighty power who oversaw the world and was interested in human affairs struck me as utterly untenable and childish.

Yet it is impossible to be touched by something one does not believe in. That audiences are moved to tears by such works of fiction as *Romeo and Juliet* and *Death of a Salesman,* while knowing full well that there never existed any such persons as the star-crossed lovers and Willie Loman, is no evidence to the contrary. On some level Romeo, Juliet, and Willie have existed, do exist, and will perhaps exist until the human race itself vanishes. It is on this level that I believed fully in Blake's sad, underachieving God.

But let us drop that idea for a moment to concentrate on other aspects of *Elohim Creating Adam.* Initially, I thought the glorious sunburst depicted the dawn coming up like thunder out of China, that the world was about to be swept by humanity's first glorious day. But, no, that is quite impossible. What defeats the daybreak hypothesis is the advanced state of both Adam's creation and his corruption. Given God's slow method of forming his would-be masterpiece, for it to be morning would require his having worked all night. Somehow I know in my bones that Blake could never have imagined God as a night person. The best time for artists is when the light is good. This statement satisfies me that at

least the Divine Artist would have commenced his task early in the day. The assumption of the sun sinking is strengthened by the downward pushing of the roiling, gloomy mass overhead that almost seems to be driving it from the sky. Realizing that night is coming increases one's insight into God's manifest anxiety. He is hurrying to finish while there is still time before the powers of darkness take over. That they have in fact begun their irresistible encroachment is evinced by the worm that has already claimed Adam's body as its own. In short, God knows already that he has been undercut.

I have said little about Adam himself. Unlike Michelangelo's magnificent giant, whose handsome face is full of dumb worship for his Creator, Blake's Adam is a starveling with visible ribs, and his expression is every bit as agonized as God's own. But where God's gaze is aware and consciously suffering, Adam's eyes are rolled back as though he were about to convulse. It only takes his open, hanging jaw to complete the impression of uncomprehending, helpless stupefaction. God's face is noble in its misery; Adam's, in its dazed dismay, is pathetic.

That he lies fastened to the ground in the stretched and strained posture of one crucified adds additional reverberations. This fusion of the image of Adam with that of Jesus is susceptible to multiple interpretations. To me it suggests not only that Adam—ordinary humanity—is as much the dearly beloved offspring of the Father-God as Jesus, but also it implies that life must inevitably be excruciating in its suffering. It is, indeed, impossible to overestimate the sum of pain in the world and Blake, as we know from his poetry, was among the most sensitive of men to the degradation and misery around him. "I wander through each chartered street . . .," he wrote, "And mark in every face I meet / Marks of weakness, marks of woe." With impotent compassion he observed the exploitation of tiny children enlisted into the wretched ranks of the London chimney sweeps, the murder of young men in wars of greed, and everywhere the chaining of human minds by superstition, religious fanaticism, and ignorance. And most of all Blake grieved over the terrible blights that Man in his false piety, perversity, and venereal morbidity caused to be visited on one of his greatest potential joys—sexuality: "But most through midnight streets I hear / How the youthful Harlot's curse / Blasts

the newborn Infant's tear, / And blights with plagues the Marriage hearse." Human suffering—that is a subject physicians should be able to get their teeth into. . . .

In quoting the poet here I have implied a little of what the darkness and serpent tail in *Elohim Creating Adam* signifies for me. The picture, however, does not define and establish the boundaries of what constitutes evil. It simply tells us that evil is present, was there from the start, and is inextricably bound up in the fabric of things. Each viewer is required to plot the dimensions of evil for himself. The more one thinks about what lies behind those lurid, slithery, and tenacious coils the more enormous in one's mind the symbol becomes. Annelid becomes anaconda, and anaconda becomes the dragon that swallows the world.

As with the symbol of evil, it is probably clear now that Adam too must be a complex concept. He is obviously not to be taken simply as the first of the race of Man whose original habitat was Paradise (an extraordinary Eden, Blake's bleak, stormy, snake-infested promontory!). Rather, as I have already indicated, he represents humanity but not, I think, the whole of it. For the Jehovah-image, unless one is content to take it concretely as exemplifying only Blake's "Old Nobodaddy" in the sky, represents humanity too, but under another aspect.

For me the God-figure in *Elohim Creating Adam* is the equivalent of that multitude of men and women who spend themselves to lighten the burdens of their less developed, less fortunate brethren. No, on second thought, I am not satisfied with that definition. It suggests that some are superior to their fellows, and implies also that the former are never sufferers themselves or the recipients of others' help and consolation, which is not true. A better definition, then, is that the God-figure represents Man as helper, healer, consoler, teacher, builder. The implication then is that He is Man when he is good, creative, caring, selfless, and courageous. It represents, to be even more exact, a spirit *in* humanity—those propensities in Man that we think of as most truly human and admirable. By contrast, Adam—and we are all also Adam—is Man in need of help. Included here would be the frail, ill, ignorant, poor, oppressed, and the young.

Part of the agony of Blake's Father-God stems from his role as parent. Adam is the being he loves, whom he has brought forth in

his own likeness, and for whose happiness he has tried—in vain—
to create a world free from pain. He molds his offspring as per-
fectly as he can, tries to make a fine, robust, happy creature out of
the original clay. But he knows full well how much is out of his
own control, and he gazes into the howling winds of the future
full of apprehension, anxiously bracing for the trials and sorrows
life is sure to inflict on his precious child. God, then, also repre-
sents the spirit of parental love.

Taken altogether, the theme is undeniably somber, not to say
pessimistic. Yet the design itself, in its radiance and expansive-
ness, belies that somberness. Would not a narrower, duller palette
have been more appropriate for the illustration of such a dim
view of the perfectibility of Man? Yes, if what I have so far
inferred all of Blake's message.

But there is that subtle link with Jesus. The Cross is not only a
symbol of death, but of redemption through suffering. And here
I must speak again of the artist himself. For if ever there was a
man capable of transmuting grief into glory it was William Blake.

When I first fell under the spell of his strange designs and even
stranger poems I grew curious about their maker. The first study
of Blake I lighted on was G. K. Chesterton's. In Chesterton's mind
there was no doubt that Blake had been possessed by devils, very
real, actual devils. Reading this work had a decisive and indelible
impact on my entire life: henceforth, I never read another word
of Chesterton's.

Subsequently, through works such as Gilchrist's *Life,* I came to
know something of the extraordinary artist. When Blake was a
small child a face appeared at the window of his home. It was God
himself looking in! At this pointed attention the little boy, having
previously known his creator by reputation, naturally screamed in
terror. Then, some time later, he came home from school and
remarked to his mother that on the way he had noticed, roosting in
a tree, a group of angels. She did not take him at once to a Child
Guidance Clinic (this being about 1762) and until he died at the age
of seventy, Blake continued to hallucinate copiously in both the
visual and the auditory realms. Another of his stupendous paint-
ings, *The Ancient of Days,* was copied directly from the model which
materialized at the top of his stairs, and I do not doubt that *Elohim
Creating Adam* started with a similar hallucination.

In their scholarly dissertations, admirers of great, "crazy" artists always rationalize their subjects into models of mental health. In a sense I support this, for anyone who can produce works like *Elohim Creating Adam* has a psychological vigor that might well be the envy of all of us. Nevertheless, Blake *was* crazy, and he suffered from his craziness despite his loyal wife's public assertion that he dwelt always in Paradise. (Catherine also claimed her husband's skin "didn't dirt" in response to complaints of his not bathing.) Ample proof that Blake's hallucinations were not by any means always friendly to his creative genius can be found on any page of the *Prophetic Books*. Blake took down these long, autistic, mythological poems at the dictation of his voices. Although full of fine poetic flashes, the *Books* as a whole range from obscure to incomprehensible, and no commentator has ever succeeded in deciphering them satisfactorily, although many have tried. The problem is compounded because Blake established no fixed sequence of pages, being quite indifferent to the order in which they were read. And there are other embarrassments on the path of the "perfectly sane" hypothesis. One night the voices told Blake to get out of bed and walk to some distant place (I think it was Lambeth). He and Catherine dutifully did so, and on their arrival they awaited the next message telling them how to proceed. "Now return home again," said the voices.

If the uses of adversity are sweet to adversity's victim, the uses of insanity—the most tormenting of adversities—must be the sweetest of all. Like Strindberg, Dickinson, and certain other artists, Blake was courageous and resourceful enough to extract order from disorder, to harness the rampaging energies of his psychopathology to the beautiful chariot of his talent.

Is that not one of the redemptions of Adam's invisible cross?—Adam in agony: Blake the man clasped tight in the coils of recurring madness; Jehovah in agony: Blake the artist laboring to body forth the noble and wholesome, and knowing beforehand that his creations cannot escape many a blemish. Christian tradition has always held that beatitude can be wrung from suffering but, as Thomas Mann warns us in his reflections on Nietzsche, perhaps it depends on who is sick. Or, on a more ordinary human scale, does it not depend on one's attitude to pain and on the posture of those who minister, such as the physicians . . . ?

As with universal laws of geometry and physics, the precepts of art must be relevant to the specific case if they are to be truly universal. And with this consideration we return to the individual medical student and doctor of medicine. Though my observations and inferences so far have certainly had their subjective element, I have nevertheless examined Blake's painting in terms that might be teased out by anyone. The question now is: what, if anything, has my long experience of *Elohim Creating Adam* contributed to my life as a person and, especially, as a physician?

First of all there can, of course, be no simple one-to-one relationships. Moreover, I doubt that any work of art can put anything into a person that is not, at some level, there already. Rather, art awakens an aspect of ourselves, and keeps reminding us that it is there. If the artwork, no matter how great, does not mirror something in our own nature we simply do not respond to it.

For example, although I love Beethoven's music, his *Missa Solemnis* has always left me strangely unmoved. Once a musician complained of this very thing to Toscanini. "The difficulty is that you are stupid," explained the Maestro tactfully. Undoubtedly, because we cannot find ourselves in them, all of us are "stupid" in the face of some masterpieces.

Picasso and I evidently have little in common. Although he has not discernibly found this an insurmountable handicap, I, nevertheless, find his "classical" phase insipid, his cubist phase wooden, his famous line inexpressive, his coloring blah and his whole approach too messy to be borne. Picasso! The artist the critics say is the greatest of our century! Alas, I am doomed to take their word for it—or not (if I am feeling puffed up).

On the other hand, if I tell you what *Elohim Creating Adam* means to me I can only do so by talking about myself. But there is no help for it, that I can see, if I am to limn the other hemisphere of the art-physician microcosm. To plunge then.

Whenever I look at the straining, sad face of Jehovah it invariably calls forth in me a tender feeling for the struggling builders of *my* world. That emotion becomes then the opportunity to link Blake's vision with everyday existence. This requires associational thinking; if I can overcome my repugnance for the exertion, I find that my gray matter begins to color up, and I see my mundane circumstances in greater depth and sparkle. Thus, identify-

ing myself with the incomplete and unpromising Adam, the Creator then becomes for me all that army of men and women who over the years have tried to mold my intractable clay in an effort to help me amount to something. These include my parents and other relatives, my wife, my teachers, mentors, and friends, plus a host of benefactors whose faces I have never seen—such as the unknown donor of a fellowship granted me in college.

When I was young I was often extremely hard on my teachers, not realizing that the ability to teach is a gift few pedagogues possess. Also, I grew positively bitter over the clergy who seemed to me to share the perversity of teachers without their habit of intellectual honesty. With the egocentrism of immaturity I believed I had talents that no one recognized or was willing to encourage, and I felt force-fed instead on foam and dust, and I resented it. Often, it seemed, my parents did not understand me, though I made little effort to explain myself, and my businessman father, especially, appeared to live in a world in which he only reluctantly made room for me. And so on. I blamed everyone in sight and was unhappy.

What I did not know was that most of these people—teachers, ministers, parents—were earnestly trying to do a good job. It never occurs to the young that professors have families, worries, fears, and illnesses which may prevent them from devoting every drop of energy to midwifing the potentiality of their charges. Or that the clergy may themselves be bound by the same "mind-forged manacles" (Blake, again) that they, with the best intention, often feel driven to throw around others. Or that parents have needs, longings, and desperations of their own.

Of course these human beings did not give me everything I wanted, or knew I needed. But even if they had I would never have become the consummate adult every adolescent wants to be. When I consider realistically the clay they had to work with, I sometimes wonder that they tried as hard as they did, and all of us must place some blame on our inherent limitations and defects. There are no infallible builders and nurturers—that is one of the messages that comes to me from Blake's painting. A corollary is that, results to the contrary, human beings are often doing wonders with what they have to work with. Even Jehovah who had an incredible way with ribs never, so far as is recorded, succeeded in making a silk purse of a sow's ear.

Thus, with a little license, one can see that the creating God stands for all those who struggle to produce a good, often with shoddy materials. Probably, deep down, we all have compassion for those who try, provided we realize they *are* trying. Some days, I confess, I am apt to get down on the human race and find myself echoing the seventeen-year-old Emily Dickinson's verdict: "I don't think folks are much." Occasionally, dark moments come in psychiatric practice at the publicly-supported clinic where I work when it seems as though every patient is deliberately messing up his life, having a high time in the process, and then coming to me to get the pieces put together. Husbands beating wives, mothers beating children, fifteen-year-olds getting pregnant and having abortions, everybody unfaithful, everybody stoned, nobody going anywhere except, perhaps, to hell. Yet, if there is one thing my professional experience has taught me it is this: that most people, no matter how sorry-appearing their actual performance, are really doing the best they can, given their lights and their circumstances. I agree, therefore, with Ogden Nash who maintains that there is not one crabgrass in the garden who would not rather be an azalea. Life, in our complicated, mechanistic, unfeeling age, is often too much for many of us and presents many problems that we are not equipped to solve brilliantly. Yet, were I the ultimate grader, I would give most of my fellow men an A—or at least a high B—for effort. (And that even includes you, Señor Picasso.) But when I am feeling cynical and misanthropic is when I find that the likes of *Elohim Creating Adam* can reawaken my sympathy if I will only devote to it a little contemplation. (Or perhaps it is my conscience that it reawakens.)

The immediately preceding paragraphs are from the point of view of Adam forgiving God his limitations and frailties and generously taking some of the blame on himself for the mess that resulted. But this is only half the story; one must consider how things look from God's angle, too, for in Blake's cosmology each of us shares a double aspect and a divided responsibility. It follows therefore that I, medical student and physician, must at times be Jehovah himself. (I would hate to see that sentence quoted out of context at the psychoanalytic institute.) And when I am Jehovah—that is, the struggling, toiling one in the face of formidable odds—the painting has another message for me. Then I gaze at the anguished face and feel sorry for myself and for all

those who are attempting the impossible. (A little self-pity is salutary; it is the antidote to hubris.) And the feeling makes me want to say tenderly to God:

"Relax, you are trying too hard. You left yourself one day in which to perfect Adam and that was unrealistic in view of the ambitiousness of the task. Also, try not to be so perfectionistic. Everything worth doing at all is worth doing half-assed. Of course, you will be held responsible for the results, and you must be big enough to take the criticism. Besides, if *you* don't do the job, who else will? The important thing is not that every loose end be tied up and that you come in with flying colors. The important thing is that the main objective be achieved; so don't be too fussy about style. As the English say, just keep muddling through and things will eventually shape up. As for that fellow Wilde, ignore him; you've got the ability, God. It's just that you fiddled around for five days out of six and then tried to cram. Next time pace yourself, plan your schedule a little more carefully. Fortunately, tomorrow is Sunday. Do me a favor: get yourself some rest and relaxation. Remember, you're not as young as you used to be."

This advise to my Jehovah-self persuades me that patients are best off when they are treated by able physicians who are balanced, personally contented, and fulfilled. The tense, harassed, exhausted doctor who lives and breathes nothing but medicine day in and day out cannot, I believe, be to his patients what they and society require him to be. I know this is true in my own field of medicine where one cannot take on the psychic burdens of other men and women day after day without respite and sources of spiritual refreshment. Those who attempt it become burnt-out and no longer responsive to the other person's pain. Somehow one's sensibilities must be protected from induration, one's compassion and view of the whole (patient and society) kept alive and supple and growing. The incitements of *Elohim Creating Adam,* and those of the hundreds of other masterpieces of equal caliber, may help to accomplish this in the ways I have tried to suggest— and in myriad other ways, for art is an inexhaustible cornucopia.

Recently, I was in London again and for the first time was free to visit the Tate Gallery. Filled with eagerness and much anxiety that the great watercolors might for some reason not be there, I went from room to room breathlessly searching. How close, I

wondered, had I come in my attempt as a young man to reconstruct the original from the tiny print? Would I meet an old, familiar friend or would I find, staring at me from the wall, the disquieting look of a stranger? I suddenly blundered into two whole roomfuls of Blakes, rushed overwhelmed past a row of them and—there it was.

The impact was like hearing again a thoroughly known and loved Beethoven symphony. But new it was as though presented by Toscanini: in full clarity and life, with all the fog and dust swept away, and all the lambent atmosphere remaining. It was paler than I expected, and infinitely more ethereal and graceful. Most wonderful was the fluid linearity, the masterly draftsmanship that was so sure, flexible, and carelessly right. How dead, dry and wooden was my version compared with this living thing! Usually it hurts when one is so thoroughly bested, but not in the case of art, for the beautiful confrontation is its own anodyne.

I am reminded in this context of a perverse little story by Somerset Maugham. As I recall it, a young man who passionately loves music and who is a good pianist is consumed with ambition to become a great performer. His parents, though they were financially well off, want him to devote his life to something less chancy and more practical. Nevertheless, they are willing to let him test his talent. They reach an agreement with him allowing him to devote himself exclusively to study for one year with the best teacher of piano available. At the end of that time he will either continue with his instrument or he will go into some safe but soul-killing profession, such as sales or teaching. To decide the matter, the parents will call in a recognized authority before whom the youth will audition.

The young man applies himself diligently until the anniversary of his compact with his parents. They then arrange for a renowned woman pianist to come to the house to hear their son. He plays for her, putting his all into the effort. When he is through there is silence, for the artist says nothing. With a compasionate look at the boy she takes his place at the piano and plays again the piece he has just finished. The warmth! The effulgence! The difference between her version and the boy's is like day and night, and he is crushed by the contrast. The great artist now seeks to comfort him. She tells him that, although he can never hope to

reach his goal of artistic greatness, he will always possess some-
thing that is almost as precious: the ability to recognize and re-
spond to greatness. The parents are satisfied, and the kindly vir-
tuosa takes her leave. The boy then goes out and kills himself.

That ending strikes me as utterly wrong-headed and melodra-
matic. But the words of the woman artist have always moved me.
Surely one of the loveliest boons that can befall one is the capacity
to worship great art yet not be able to bring it into existence
oneself, for then it can never lose its air of miracle.

Many physicians paint and sculpt, some competently, but that is
really not necessary in order to revere the works of genius, to
glory in them and refresh one's self thereby. Art can do this for—
perhaps not all—but at least for many of us, provided we are
introduced to it early and sensitively, and if it is thereafter woven
into the fabric of our experience. The premed forced to subsist
on a Spartan diet of biology, chemistry, physics, and German is,
fortunately, a thing of the past. But there still exist medical practi-
tioners who believe that the only excuse for their having eyes is so
they can differentiate lichen planus from psoriasis. Not that this is
not important. But it is not everything.

In this little tribute to a picture I have not, by any means, begun
to exhaust the reserves of meaning and beauty in even the single,
small watercolor under consideration. As for the art of painting as
a whole, it offers a window on imponderable reaches of history
and the labyrinthine extent of Man's religious and ethical con-
cerns. All I have been attempting , therefore, is to disclose a few
facets of one shining molecule, to strive, as Blake says, "To see a
World in a Grain of Sand."

Is an affinity for painting an absolute prerequisite for being a
full and feeling person? Of course not; nor is it indispensable for
developing a wide and compassionate view of Man and Society.
There have been giants for whom the graphic arts were as a
closed book. Homer and Milton were blind, and Wagner—any-
thing but an unfeeling man—looked coolly at paintings and
wondered at the enthusiasm of his friends. Nor is an awareness of
art any sort of precondition for practicing the finest medicine. We
have heard of physicians who lost their vision and nevertheless
managed to remain excellent cardiologists, internists, and psychia-
trists. One person relies more heavily on a particular sense than

another does, and there are probably corresponding discrepancies in the visual and auditory cerebral centers in different individuals. Some undoubtedly hear the music of the spheres without having to resort to telescopes. And then there are undoubtedly some who perform best if they are not too open to the world and to their inner depths. Great art temporarily dismantles us before it glues us back together, and that may be agitating for those whose intellects are intact enough but whose emotional controls are fragile and under hidden stress.

But these are relatively few, I think, and most medical students and physicians could only profit as persons and as practitioners by a richness of aesthetic experience in their lives For those young people in whom vision is naturally a channel for harmony, depth, breadth, and enlightenment it seems important that premedical and medical education do everything possible to keep the channel full and flowing. The spirit, like a plant in a desert, needs its watering and, in the visual-minded, is much dependent on the eye to keep it green and fruitful.

Although as a nonphysician medical educator I have no real competence in either medicine or the visual arts, I appreciate how important they are as means of knowing, experiencing, and communicating with each other. Consequently, I believe that art is an essential component of human culture and not merely a luxury. Such a statement is obviously in direct contrast to the views held by John Cody. Because art represents a form of cognition, I believe it should be an intrinsic part of the educational process. In this paper I suggest two propositions which have grown out of these basic assumptions. The first is that renewed emphasis on education in the arts is especially needed in our current situation; the second that art can be made a functional, meaningful, and relevant part of medical education.

9

Among Other Things, Art

E. A. Vastyan

"As visual art is nonverbal, moreover, it may transcend the visual boundaries created by linear and verbal presentations. Depending on how it is utilized, art may function to . . . advertise, celebrate, clarify, communicate, decorate, discover, educate, enhance, entice, express, heal, inspire, integrate, intensify, interpret, narrate, organize, protect, record, refine, reveal, transform and visualize, among other things."[59]

Though for the purposes of this essay I speak about "art," I am using the term in a much broader sense to include what I shall call "the humanistic disciplines." Distinctions between "art" and "humanistic studies," and within each term, are obviously necessary

and can be made with some clarity. Except in cases in which I have made explicit distinctions, however, I have used the terms almost synonymously—quite simply as "disciplines" or means of knowing and experiencing which differ in certain common ways from the biological, physical, and social sciences.

An autobiographical note seems in order at this time because of its bearing on both the shape and the direction of the argument I wish to make. While my discipline is the field of religion, I made a deliberate decision to practice that discipline within medical education. My decision was built on rather ingenuous enthusiasm, but also on reasons to which I still subscribe. By the fifties it was abundantly clear that our culture was going to be marked primarily by massive transformation; that, as Elting Morison put it, rapid change had become the steady state. While much of the turbulence was political and social, it was clear that the chief agents of change were science and technology, through an avalanche of new knowledge and technique.[60]

I had begun my professional career just as *Sputnik I* had been launched, with not only intense technological enthusiasm, but a massive and well-funded federal commitment "to catch up to the Russians," to produce even more knowledge and to apply it to social priorities—in short, to produce, overnight if possible, a thoroughly technological society. With those in the sciences I shared both enthusiasm and hope—and also dread. For the clock face on *The Bulletin of Atomic Scientists* had continued to move ominously closer to midnight. In our time, we had come to know firsthand how each attainment of greater good bears within it the seed and potential of even greater evil. How our society could survive the gifts of science and technology had become a question that had to be asked; how our society would adapt to the new scientific revolution had become a common agenda for all of us.

The chief stage wherein attempts to adapt the new scientific revolution to human purposes and human scale could possibly be worked out seemed to be in medical education. Here was the crucible in which would have to be melded a dependence upon research and discovery, a continuing dedication to human priorities and human scale, and a definitive commitment to serving both individuals and the common good.

Since the dawn of modern society, each generation has reaped

benefits at an ever increasing pace. However, the past forty years have wrought transformations in exponential leaps. In terms of science and technology, the world of my children has been as different from the world of my childhood as that world was different from the world of Christopher Columbus. Knowledge is said to double every five years; 90 percent of all scientists who have ever lived and worked are alive and working (and publishing) today. The impact of such new knowledge on culture has been evident from the beginnings of science; so, too, from the very first, there has been social discomfiture and resistance to change.

But our problem is no longer simply whether we can overcome resistance and accept rapid change as the steady state. Rather, it is whether we can continue to adapt to such turbulence and still remain human. In probably no other field are the questions of human scale, human priorities and human values more critical, and even more in confrontation with technological preemptiveness, than in medicine. For in no discipline has concern for human values, concern for the individual, been more vital. That it would never render concern for the person secondary to a body of knowledge, or to a repertoire of technological skills, has throughout history been medicine's chief principle. Yet there is deep concern today whether physicians will continue a commitment to persons as primary—above a commitment to technology or to a body of knowledge.

Nor is concern about medicine's increasing dehumanization limited to malpractice litigants or even to patients; it is clearly evident among medical students and medical practitioners as well. They, too, share a feeling of being harnessed to a system of ever increasing complexity; they, too, share an almost desperate inadequacy in keeping abreast of vital new knowledge, and the constant threat of professional incompetence or obsolescence. Most resist, with disconsolate poignancy, a host of urgent demands that compromise the meaningful human relationships for which they entered the profession.

How to restore or maintain, revitalize or clarify further the human priorities within medical education has become the heart of the matter. Such questions have been the subject of countless meetings on research and reform in medical education, and nu-

merous tactics and strategies are being tried. In all probability, no single "solution" will return human values to a central focus. The need to attempt alternate pathways—in the effort to keep medicine attuned to innovation, and yet preserve its commitment to human values and priorities—seems obvious.

One of the paths in medical education has been the attempt to rebuild and regenerate ties with the humanistic traditions in which medicine has been rooted, through a series of educational experiments thrusting humanistic disciplines into the midst of medical education itself. But returning human values to centrality in medical education is clearly not a matter of simplistic solutions. The changes forced upon medicine by new knowledge represent permanent, overwhelming transformations. "Solutions" will come from neither a nostalgic longing for a simpler past, nor from the most heartfelt humanitarianism. They will come, if at all, only from coherent strategies and concerted efforts—and, I am deeply convinced, such efforts must be directed toward fundamental conceptual reform as well as toward curricular change. The aim cannot simply be the addition of even more information; the aim should be at understanding the ways knowledge is discovered, learned, valued, and used—in developing professional behavior patterns that best serve human ends.

Within such strategies, I believe the humanistic disciplines can play a vital role, and that art, or the "visual arts," should be among the disciplines included in the attempts, but it is important that we try for some further clarity in the use of both terms. In describing meaning in the visual arts, Erwin Panofsky helped in this clarification:

Historically the word *humanitas* has had two clearly distinguishable meanings, the first arising from a contrast between man and what is less than man; the second, between man and what is more. In the first case *humanitas* means a value, in the second a limitation. . . . It meant the quality which distinguishes man, not only from animals, but also, and even more so, from him who belongs to the species *homo* without deserving the name of *homo humanus,* from the barbarian or the vulgarian who lacks *pietas* and *paideia*—that is, respect for moral values and a gracious blend of learning and urbanity which we can only circumscribe by the discredited word "culture." In the Middle Ages this concept was dis-

placed by the consideration of humanity as being opposed to divinity, rather than to animality or barbarism. . . . Thus the Renaissance conception of *humanitas* had a two-fold aspect from the outset.[61]

My use of the terms "humanistic studies" and "art" presupposes such roots. As the pillars upon which Western culture was built, until the advent of science, humanistic studies would have encompassed all that was meant by "learning." Thus, in the rationale I seek to outline briefly below, my references to the humanistic disciplines and art will be primarily concerned with *ways of knowing (and knowledge); with *ways of ordering (and values); with *ways of choosing (and commitments); with *ways of perceiving (and sensibility);* and with *ways of acting (and skills).* Such arts have roots in both *epistēmē* and *praxis:* they are concerned, on one hand, with how we know and discover and learn; on the other hand, with how we put all this into practice.

Let me elaborate a bit more, for in his essay John Cody spoke of both humanistic disciplines and art in ways from which I wish both to distinguish my argument and differentiate my purposes. It seemed to me he almost entirely equated "humanistic studies" with "humaneness," and "art" almost entirely with "emotionality." For instance, he questions whether such studies can "render one more humane," and uses about thirteen adjectival clarifications—including "large of heart," "kind," "selfless," and "public-spirited"—to explain this use of the word. Art is almost entirely relegated to the realm of emotionality ("enhanced emotional responsiveness"), which I certainly also see as one of the benefits of the arts, but hardly the only one.[62]

But a bit more. Dr. Cody went to some lengths to suggest that humanists can be charlatans, and that artists can be callous; that knowledge does not "produce" virtue, and that art does not "produce" sensitivity. Agreed, of course. But we should look a bit further: doing justice usually involves knowing something about justice; doing "good" implies some ability to distinguish it from "evil"; and a person of refined sensibilities implies some knowledge of order, proportion, and appropriateness.

My argument should not be taken to deny that education has little or nothing to do with "humaneness." Quite the contrary, I do argue that we should not limit our understanding of humaneness to either emotional or moralistic connotations. Moreover,

that we should not try to arrogate to humanistic studies or the arts our concern with "virtue." All disciplines of the mind must bear a responsibility to seek the good. As Raymond Aron has pointed out, there are values traditionally regarded as preeminently *scientific* virtues: "regard for facts, sound reasoning, trust in other scientists, a critical attitude toward oneself and toward evidence — in short, prudence, humility and deference to truth."[63]

Can Humanistic Studies Contribute to Medical Education?

The assumptions upon which René Dubos based his Silliman lectures posed a clear challenge for both medicine and the humanistic disciplines;

All biological questions regarding man must be seen in the light of the fact that he is a social, thinking, sensitive, and ethical animal. These attributes are at least as important for understanding him, and for dealing with his medical problems, as are the chemical structures and properties of his body machine. . . . Indeed, medicine would lose much of its relevance to the welfare of man if it were to limit itself to problems that can be analysed by the orthodox techniques of physiochemical sciences. . . . What is needed is nothing less than a new methodology to acquire objective knowledge concerning the highest manifestation of life—the humanness of man.[64]

The Millis report, rendered to the American Medical Association in 1966, echoed Dubos' challenge:

What is needed—and what the medical schools and teaching hospitals must try to develop—is a body of information and general principles concerning man as a whole and man in society that will provide an intellectual framework into which the lessons of practical experience can be fitted. This background will be partly biological, but it will be social and humanistic, for it will deal with man as a total, complex, integrated, social being. Clearly there must be a considerable amount of experimentation on the part of the schools . . . to arrive at the most satisfactory subject matter and methods of teaching. The immediately important thing is to have a clear and definite resolve to impart this new body of knowledge.[65]

Many took obvious cheer at such recommendations. For while both Millis and Dubos were ready to concede a knowledge explosion far beyond any four-year degree boundaries, both seemed ready to concede as well the need for new criteria about what was essential. Yet it seems that both stopped short in their reasoning. Though they had argued cogently about the *process* of learning, neither had carried the argument beyond the concept of "a new body of knowledge." Both men failed to ride the breakers over two shoals which endanger passage to any really fundamental reform in medical education.

For if medical education cannot ignore the stark reality of exponential growth in essential knowledge, on one hand, neither can it ignore finite human capacities to absorb and utilize that knowledge. "There is, perhaps, one universal truth about all forms of human cognition: the ability to deal with knowledge is hugely exceeded by the potential knowledge contained in man's environment."[66] To such a dilemma, medical education has responded in a number of ways: reduce factual input to a lean, bare "core curriculum" and foster "self-education" and "continuing education"; rearrange factual content according to carefully designed "behavioral objectives"; encourage self-motivated learning through independent research; order the knowledge in smaller vessels and facilitate earlier specialization; and, of course, probably the most efficient and effective, the oldest model of medical education—teach clinically, at the bedside, harnessing a student's motivation by wedding *epistēmē* to *praxis*.

Added to such pressures is another which haunts all professional education but which is especially forceful in medicine—the fact that the granting of a degree is, for practical purposes, a form of public licensure. Though the state has retained formal authority to designate a professional person ready to exercise dangerous (and potentially lethal) functions, in medicine, at least, an M.D. degree is in reality the keystone of the professinal arch. Few fail "state boards."

Before returning to Dubos and Millis, I would like to add another personal observation. Even if we would disregard these pressures, since the Flexner Report medical education has been one of the most powerful, effective, and efficient educational methodologies Western civilization has devised. Within four years,

bewildered youths are transformed into relatively poised, knowledgeable, and capable bearers of life-or-death responsibility. Nationally, only about 4 percent of those who enter medical school fail the academic muster; even fewer, by changing careers, fail to devote a lifetime to the practice of the profession. Given these facts, there can be little wonder at the deep conservative bias against change in medical education; indeed, medicine's very real commitment to research, experiment, and exploration in pedagogy must be seen as all the more remarkable. And all the more urgent—for it marks a patent recognition of the need for change.

How can we deal with such dilemmas in medical education? Becker's *Boys in White* described certain coping patterns that still exist among many medical students.[67] Entering students, he pointed out, had a zeal and purposiveness that was not yet diminished by awe—"I'm going to learn everything that's really important." But by the passage of the first midterms, the new standard was obvious—"I'll learn what will be asked on exams." Such a process has caused clucking dismay among teachers, and engendered papers with such titles as "The Fate of Idealism in Medical School."

But, a *caveat:* before we ourselves dismiss this conclusion cynically, we should look a bit deeper. For such students are doing—albeit with inadequate criteria—what good minds habitually do. They are creating organizing principles to order and channel the powers of their minds. In their ingenuous and often anxious fashion, these students have begun to resist what Santayana spoke of when he described pragmatism as "the philosophy of the dominance of the foreground." They have begun to cope with a weakness to which formal education is always susceptible, "the sustained and peremptory dominance of subject matter."[68]

Medicine has always been particularly vulnerable to that dominance. Teachers too easily allow subject-matter, often defined in a very limited sense (frequently, "my research") to engage the largest share of their attention. Among such, there's a quick readiness to be convinced that their work is done when so many items of information are imparted—however inaudibly, however inexpertly. What can be called the "Hydraulic Theory of Learning" seems to predominate, especially in the vital preclinical years of concentration on basic sciences. Hydraulicism suggests: (a) that

whatever is poured into a finite container is totally retained; (b) that all that goes in, goes in without bubbles and occupies equal space; (c) that whatever is displaced here must bulge out there; and (d) that once in, there simply is not room for any more.

Yet most of us sooner or later come to realize that that which we forget is every bit as important as that which we remember. As William Walsh puts it in his *The Use of Imaginaton,* "Some simple learning and skill aside, few of us, unless professionally required to do so, could or would wish to recover from the discard into which our minds have thrust it, much of the truck on which we and our teachers spend effort, energy and patience at school."[69] What we have forgotten may be trivial and of no use to us. But, more important, what we have forgotten has probably modified our minds and shaped our perceptions in such a way that it is no longer an object of thought, but a means of insight—a part of that more or less coherent, more or less complex, more or less sensitive unity of self that is our only instrument of learning.

From lifelong studies of learning and perception, Jerome Bruner reinforces Walsh's observations:

> Though the idea of economy in metaphor is by no means novel, it is worth special mention in a discussion of art as knowing, for it is precisely in its economy that art shares a fundamental principle with other forms of knowing. . . . We have learned too that the "arts" of sensing and knowing consist in honoring our highly limited capacity for taking in and processing information. We honor that capacity by learning the methods of compacting vast ranges of experience in economical symbols—concepts, language, metaphor, myth, formulae. The price of failing at this art is either to be trapped in a confined world of experience or to be the victim of an overload of information. What a society does for its members, what they could surely not achieve on their own in a lifetime, is to equip them with a ready means for entering a world of enormous potential complexity . . . by providing the means of simplification—most notably, a language and an ordering point of view. . . . The corresponding principle of economy in part produces the compact image of symbol that, by its genius, travels great distances to connect ostensible disparities.[70]

Let me digress a bit. Such ideas as Bruner's reinforced for him by his investigative methods, have, of course, been around for quite some time—from Socrates to Jeremiah to Jesus of Nazareth.

But it seems almost necessary to rediscover them in each genera-
tion and rework them for each particular educational challenge.
Thus, those of us who have been part of the movement that has
tried to reappropriate the power of the arts and humanistic
studies for the purposes of medical education have been faced
with the need to justify—and not merely rationalize—our efforts.
We have known that there is no easy bridge from "humanistic
studies" to "humanistic medicine," though many have challenged
us to describe the bridge in simplistic terms. What has excited me
about the dialogues sponsored by the Institute on Human Values
in Medicine has been the serious effort, no matter how inchoate at
times, to grapple with fundamental root assumptions about how
we know and how we learn, an inescapable task if we are to go on
to decide how (and what) we teach.

Throughout these conversations, the name of Samuel Taylor
Coleridge has kept recurring to me; the more I have pondered
our challenge, the more analogous, it seems to me, was the situa-
tion Coleridge faced in his day. Rightly, I think, Coleridge has
been called the individual of the truly modern consciousness. He
stood at the brink of Pope's ordered eighteenth-century world,
watching it pass to the intellectual turbulence of the nineteenth
century. He was able to foresee, I believe, ours as a world in which
Pope's sense of God and order and accepted categories would be
entirely gone. His brilliant but scattered works on education anti-
cipated many of the questions we are asking; he felt obliged to
offer answers to questions which had never even been formu-
lated before. And both his questions and answers were to em-
power and light the greatness of the universities and public
schools of nineteenth-century England. We might do well to
pause with Coleridge briefly. To allow ourselves to be dominated
by the foreground, to Coleridge, represented "the plebification of
knowledge." Reason, to Coleridge, was to seek the "pertinent
connectives"; reason was a source and organ of self-consciousness
that contained the "power by which we become possessed of prin-
ciples." He wrote in the *Biographia Literaria:*

The intercourse of uneducated men is distinguished from the diction of
their superiors in knowledge and power by the greater disjunction and
separation in the component parts of that, whatever it be, which they
wish to communicate. There is a want of that prospectiveness of mind,

that surview, which enables a man to foresee the whole of what he is to convey, appertaining to one point; and by this means so to subordinate and arrange the different parts according to their relative importance, as to convey it at once, and as an organized whole.[71]

What Coleridge described were huge powers of the principled rather than the cluttered mind, "the germinal power that craves no knowledge but what it can take up into itself, what it can appropriate and reproduce as fruit of its own." He sought those "fine and luminous distinctions" which described the ability to make pertinent connectives as resting upon three powers: "wit, which discovers practical likeness hidden in general diversity; subtlety, which discovers the diversity concealed in general apparent sameness; and profundity, which discovers an essential unity under all the semblance of difference." For him, the error of education expressed itself through the determination "to shape convictions and deduce knowledge from without by an exclusive observation of outward and sensible things as the only realities" while retaining an obstinate inattention "to the simple truth that as the forms in all organized existence, so must all true and living knowledge proceed from within." As the objective of education, Coleridge described a rich and plenary concept of the *self*—"not merely as intellect, but the whole concourse of cooperative mental powers, of thought, feeling, purpose and imagination."[72]

So, it seems to me, our efforts in medical education must be to utilize humanistic studies and the visual arts towards the building of enriched and enlarged concepts of the self, especially the professional self. For a large part of the perceived malaise in medical education (and practice) is that technology has forced physicians into an ever shrinking, increasingly narrowed professional role. The astute observation Alfred North Whitehead made in 1925 has much applicability to our task today: "The fixed person for fixed duties, who in older societies was such a god-send, in the future will be a public danger." For too many, professional maturity has come to mean a narrowing into a dull, resigned acceptance of a limited self. What we should seek, I believe, through new forms of medical education, are the sources of change, which can enable fresh concepts of professional self-images.

My basic assumption is that such a task is worth undertaking; that it is an inherently interdisciplinary enterprise; that the meth-

ods and insights of visual arts and the humanistic disciplines do complement those of the medical disciplines; and that they can be melded in the most effective, imaginative approach to common problems and toward common goals.

The Penn State Experience

Numerous papers have described the ten years of experience we have had at Hershey with humanistic studies in medical education. Here I can only highlight some of the inferences we have drawn.

Obviously, the six of us who teach in that program represent not only different disciplines but different points of view, yet we largely share the educational philosophy I have tried to represent in this paper. In one of our earliest planning documents, for instance, we affirmed that

diagnosis, medical care and clinical judgment function in a cultural context that embraces the complexity of man's world, his values, and his historical legacy. Many nonmedical disciplines have studied man for ages and know him with some intimacy—his belief systems, his values, his languages, his thought patterns, his life-styles. Our primary objective is to help educate physicians who see medical practice in a context that is comprehensive—that emphasizes and enlightens, rather than avoids, the rich coplexities of man, his society, and his heritage.[73]

We have shared, too, the need for personal commitment to new forms of teaching. While scholars committed to the humanities may be convinced of their intrinsic value, their place in medical education is neither self-evident nor self-validating. The humanistic disciplines must be effectively translated into the idiom of medical education. And teachers of the humanities must be ready to transfer their professional habitat to the medical environment, to demonstrate their concern for its questions, to share its daily life.

Throughout history, the humanistic disciplines have had as their objective the preservation, promotion, and refinement of what it quintessentially means to be human, in a human·culture. From Socrates' "Know thyself" to Saul Bellows' 1976 Nobel Prize

acceptance address, humanists have struggled to identify and describe those values which define the human self, which enrich the human spirit, and which embody human culture. We have tried to keep a constant focus on values—to help identify, elucidate, and clarify their centrality. We have subsequently found that our teaching had been directed more and more towards the elucidation and development of what we could term "humanistic skills." For as we were bending efforts to sharpen perception, to foster perspective, to educate sensibilities, to develop critical reflectiveness, to liberate imagination, we have become keenly aware that such skills are very much akin to clinical skills, and that they lie at the heart of what has often been termed "the art of medicine." A list of such clinical skills can be easily compiled: awareness, perceptiveness, empathy, discrimination, judgment, tolerance, evenmindedness, dedication, commitment, self-awareness. These are the foundations of diagnostic acumen and therapeutic effectiveness. Such skills help us "unpack" those three attributes which Carl Rogers, after long experience and reflection, termed the necessary and sufficient conditions of a helping relationship—accurate empathy, nonpossessive warmth or love, and congruence. But we have also found that such skills are rarely given explicit attention in medical education; most often, it is held that they are communicated best (or only) by role modeling or by allusion.

So, too, in most teaching of the humanities; literature and history, for example, have been called disciplines through which maturation can occur, through which the student can internalize and grow by participating vicariously in a wide range of human experience which is not personally and immediately available to him. But how he appropriates such experience, how he develops the skills of maturity which he potentially can learn from history or literature, are rarely part of the teaching. We believe such skills not only can, but should be taught, as the clinical humanistic skills of the art of medicine, and as part of the repertoire of the mature physician committed to humanistic medicine.

As a clinical skill, empathy itself is a case in point. Regarded as a key skill for the practice of any helping relationship, it is nevertheless largely ignored in explicit teaching. Instruction in physical diagnosis does, of course, teach observation and history taking, but in most instances, empathy is usually regarded as a matter of

technique that can only be gained by actual experience. But empathy is not simply a psychological concept. Every fictional character who has the ring of authenticity was created by an author who could, through his imagination, so deeply live that character's experience that he could bring it to life also for the reader. Literature, we have repeatedly found, provides a rich resource for freeing a student's imagination, a necessary accomplishment if the skill of empathy is to be mastered.

In teaching both student and faculty groups, for example, Joanne Trautmann has used the short story, "The Use of Force," written by physician-poet William Carlos Williams. About a physician (Williams himself, in all likelihood) who loses his self-control when he attempts to force open the mouth of a recalcitrant child whom he suspects of having diphtheria, the story inevitably engenders a provocative discussion of the physician's self-awareness and responsibility. A powerful, imaginative situation provides a new sense of awareness and perspective to carry to the actual experiences of practice.

In fostering education that seeks to keep values as a central focus, Walsh argues that the strongest appeal should be to the imagination:

Imagination (is) the power by which one pries himself free from the present and loosens the clutch of the immediate. In the imagination act (one) disengages himself from the partial and the broken, "from the universe as a mass of little parts," and comes to conceive of a larger unity and the more inclusive whole. The now is extended, the here complicated. The pressure of the momentary is relaxed and the actual charged with the possible. Alternative courses of action loom up and define themselves for choice. The source separates from the outcome, and the distance between act and consequence increases. Thus a centre of attribution is established, and the concept of responsibility begins its long and difficult pregnancy.[74]

Analogous skills have become the major objectives of all our preclinical teaching. Literature, in addition to fostering imagination as a skill with which to synthesize acquired data, is taught in a fashion to help the student use that synthesis to understand and empathize with people, concepts, and situations, even those at

great remove from his experience; to perceive nuances and levels of meaning in situations which previously might have been reduced to dangerous simplicity; to understand and live with ambiguity; and to express himself more precisely, coherently, and imaginatively.

History is taught to encourage an awareness of change and stability; to see problems through other "ways of looking" (i.e., through other social and medical paradigms); to show the evolutionary nature of medical problems, and that solutions to problems themselves often generate new and other problems; to demonstrate viable alternative perspectives to biological determinism; and to encourage the development of historiographic skills important in every patient contact, the ability to gauge, weigh, and attribute significance in the midst of unrepeatable events or phenomena.

Philosophy is preeminently education for the skills of critical reflectiveness, developing the ability to cut through to the core of an issue to see what is essentially at stake, and what is needed to defend or refute it. It is taught to bring into awareness the conceptual framework within which one operates in daily dealings, whether these be technical, or motivational, or purposive. Philosophical skills develop an ability, in other words, to know which questions to ask, when and how to ask them, and when an answer has been arrived at.

Religious studies are taught from a perspective aimed at helping the student understand those aspects of human life which shape one's experience of limit: finitude and mortality, fate and death, guilt and condemnation, emptiness and meaninglessness, pain and suffering, powerlessness and helplessness, loneliness and anomie; those which shape one's experience of self-transcendence and self-worth: affirmation and commitment, fulfillment, and health, responsibility and value, forgiveness and intimacy; and about the ways in which a person's responses, relating to his sense of worth and his awareness of limit, contribute both to his predicament and to his fulfillment as a human being.

As the discipline added most recently to our curriculum, visual arts likewise have been taught by an art historian who concluded, after his first rich year of experience, that art must be used to help students "increase their visual acuity, gain fresh perspectives,

become involved with the creative process, practice visual concentration, clarify and enhance verbal and written communication, inculcate a sensitivity to values, develop and increase an awareness of empathy and tolerance, and provide a celebration of life by experiencing that which is immortal and universal in the human spirit."[75]

Medical education has long recognized that teaching skills to students is one of the most effective educational strategies. When a student gains confidence that he has the requisite skills to accomplish a given objective, his attitudes and behavior usually change. He is ready to attempt more, and ready to attempt the more difficult; he develops more confidence in facing the unknown, and is more ready to learn from the unfamiliar experience. The teaching of clinical skills, we believe, should not be limited to a foundation in scientific and technical skills; clinical skills should be related, in a complementary fashion, to the humanistic skills which fundamentally differentiate medicine as a profession dedicated to the human enterprise.

Learning how to teach such clinical humanistic skills effectively—and to do so as a habitual, routine part of clinical medical education—is one of our primary aims. A coherent methodology for doing so remains to be developed, but the foundations built during the preclinical years offer clues and suggestions for methods that can be adapted to clinical education. Important, too, is the general readiness among Penn State students to learn through methods and from subject matter that have not been a part of conventional medical education.

Problems associated with emotionality offer a case in point. Concern about the way one's feelings will affect professional behavior seems ubiquitous among medical students from the first day. Various anxieties surface: about inflicting pain through such procedures as venipuncture, about sexual feelings in a clinical situation, about discomfiture in the presence of a dying patient. Anxious about their feelings, students then tend to repress, deny, and avoid feelings. What results is an impoverished sense of their own emotionality, increasingly muted emotional responses, and a marked inability to describe what they do feel. It becomes common, even among students who have suffered personal trauma, to be unable to give voice to their feelings. Consequently, two of

Rogers' three characteristics of a helping relationship are enfeebled—both accurate empathy and congruence, that awareness of one's own feelings and attitudes as they are being experienced.

In much of our teaching, emotionality is explicitly addressed. Imaginative literature is used to help them develop a vocabulary for their own emotions. Visual arts are used to help them see grief or suffering, depression or joy, and to encourage their own affective responses. Role-play situations help them experience awkwardness, anxiety, or stress, and to examine their own reactive behavior.

Yet, in many ways, we believe, we have barely scratched the surface of possibilities. Our teaching concentration has been on the first two years of medical education—where the conceptual foundations for medical practice are being laid through basic sciences. We felt it necessary to be there as well—with both depth and rigor—and have concentrated our teaching efforts in that period. But this has meant a consequent short-shrifting of clinical education, those powerful years where the student gains the confidence to apply his learning to immediate human crises. In common, our entire faculty sees this as our next frontier.

"To know is in its very essence a verb active," Coleridge wrote. From his earliest years he was conscious of his mind shaping and patterning his experiences, and he could write of his childhood, "I regulated all my creeds by my conceptions, not by my sight, even at that age." And for him, the activity of thought—as of imagination and passion—was primarily an activity of unification.

In his work *On Knowing: Essays for the Left Hand,* Jerome Bruner comments:

We know now . . . that the nervous system is not the one-way street we thought it was—carrying messages from the environment to the brain, there to be organized into representations of the world. Rather, the brain has a program that is its own, and monitoring orders are sent out from the brain to the sense organs and relay stations specifying priorities for different kinds of environmental messages. Selectivity is the rule and a

nervous system . . . is as much an editorial hierarchy as it is a system for carrying signals.[76]

In his study of hemispheric specialization, physician J. E. Bogen adds:

We have finally learned a fact about the brain which is directly relevant to everyday pedagogical practice. . . . It is, most simply, that the brain is double, in the sense that each cerebral hemisphere is capable of functioning independently, each in a manner different from the other. . . . One way to look at this new information is to see how it might apply to an ancient problem: the dichotomous nature of "knowing." I mean by this the conclusion which has been reached by a long series of students of the mind, namely, that we typically employ two different "kinds of intelligence" or (in a more modern vocabulary) two different "seas of information-processing rules". . . . If our society has overemphasized propositionality at the expense of appositionality, more is involved than the adjustment difficulties of isolated individuals. It means that the entire student body is being educated lopsidedly.[77]

Can, or should, the visual arts and humanistic studies be integrated into medical education? Surely we err if we rush to answer by excoriating medical education for its justifiably intense concern with the exploding body of scientific knowledge, or by ringing in some superficialities about "humaneness" as though we had found some antidote.

Rather, it seems evident that we must begin to explore again — with Coleridge, Bruner, Bogen, and many others — how we best "know," as a necessary prelude to exploring what is worth knowing, and how our knowing is related to our actions. If the visual arts and humanistic studies can contribute to both questions, as I believe they can, we are well on our way to sound and justifiable answers to the question, "What shall be taught?" And I believe we shall become part of a real adventure of the mind.

NOTES
NOTES ON CONTRIBUTORS

Notes

1. Medical Education: In Transition?

1. Allan W. Walldren, "Curriculum Theory and Curriculum Practice," in G. E. Miller and T. Fulop, eds., *Educational Strategies for the Health Professions* (Geneva: World Health Organization, 1974), p. 10.

2. Felix Martí-Ibánez, *Centaur: Essays on the History of Medical Ideas* (New York: MD Publications, 1958), p. 612.

3. Wayne Menke, "Professional Values in Medical Practice," *New England Journal of Medicine* 280 (1969): 930–36.

4. Henry Sigerist, *The University at the Crossroads: Addresses and Essays* (New York: Henry Schuman, 1946), p. 127.

5. *Ibid.*, pp. 107–8.

6. Abraham Flexner, *Medical Education in the United States and Canada* (New York: The Carnegie Foundation for the Advancement of Teaching, 1910).

7. Lawrence J. Henderson, "The Practice of Medicine as Applied Sociology," *Transactions of the Association of American Physicians* 51 (1936): 14.

8. Martí-Ibánez, *Centaur,* pp. 59, 64.

9. William Osler, *Aequinimitas,* 3d ed. (New York: Blakiston, 1932), following p. 451.

10. K. P. Bunnell, *Liberal Education and American Medicine: A Bibliography* (Mimeograph from the Institute of Higher Education, Teachers College, Columbia Univ., 195?).

11. Thomas E. Morgan, "A University of Washington Program to Encourage Arts and Sciences Electives for Medical Students," *Journal of the American Medical Association* 48 (1973): 758–59.

12. James Thurber, *Let Your Mind Alone* (New York: Grosset & Dunlap Universal Library, 1969), p. 74.

2. Hands Healing: A Photographic Essay

13. Personal communication from John Cody, M.D. "The sentence I had the toughest problem with was on page [11] and my changes may

completely have falsified what you were trying to say. At any rate I see EKG images, body scans and the like as simply graphic analogs of physiological processes and relationships. It seems to me that the reason the images are not art is not that they do not illuminate. They actually do illuminate for one the condition of the brain, the heart conduction, and so forth. It seems to me what is important is that they do not suggest infinite horizons the way art does. They illuminate a tiny area like a flashlight in a dark tunnel, whereas art is like the sun that illuminates an infinity of possibilities." (September, 1978)

14. Max Raphael, *The Demands of Art,* translated by Norbert Guterman (Princeton: The Bollingen Foundation, Bollingen Series no. 78, 1968).

3. The Arts Versus Angus Duer, M.D.

15. This essay has been modified from a presentation given by John Cody for the Symposium on the *Role of the Humanities in Medical Education* at Eastern Virginia Medical School, Norfolk, 29 and 30 Apr. 1977.

4. The Visual Arts in Health Professional Education

16. For an excellent resource on consumer planning of architectural projects, see Christopher Alexander, Sara Ishikawa, and Murray Silverstein, *A Pattern Language: Towns, Buildings, Construction* (New York: Oxford Univ. Pr., 1977).

17. For a discussion of public mural art, see Eva Cockcroft, *Toward a People's Art* (New York: Dutton, 1977).

18. Museum of Modern Art, *Diane Arbus,* an Aperture Monograph, special edition (New York, 1972), p. 15.

19. For a complete history and analysis of this painting, see William S. Heckscher, *Rembrandt's Anatomy of Dr. Nicolaas Tulp: An Iconological Study* (New York: New York Univ. Pr., 1958).

20. *Ibid.,* p. 28.

21. For further development of this theme, see Sally Gadow, R.N., Ph.D., "Existential Advocacy: Philosophical Foundation of Nursing," presented at the Phase I Conference of the Four State Consortium on Nursing and the Humanities, Farmington, Conn., November 1977.

22. A discussion of the Vera Icon is contained in Andre Chastel, "La Veronique," *Revue de l'Art* 40–41 (1978): 71–82.

23. Discussion of these powerful portraits by Gericault can be found in: M. Miller, "Gericault's Paintings of the Insane," *Journal of the Warburg and Courtauld Institute* (1940–1941): 151; Lawrence Bitner, *Gericault,* Los Angeles County Art Museum, 1971; and *The Detroit Institute of Art's French Painting 1774–1830: The Age of Revolution,* 1975.

24. For a thorough discussion of this engraving, see Erwin Panofsky, *The Life and Art of Albrecht Dürer* (Princeton: Princeton Univ. Pr., 1955), pp. 156ff.

25. *Ibid.,* p. 158.

26. *Ibid.,* pp. 161ff.

27. *Ibid.,* p. 171.

28. For a further discussion of portrayals of aging in art, see Geri Berg and Sally Gadow, "Toward More Human Meanings of Aging: Ideals and Images from Philosophy and Art," in *Aging and the Elderly, Humanistic Perspectives in Gerontology,* David D. Van Tassel, ed. (Atlantic Highlands, N.J.: Humanities Pr., Inc. 1978).

5. The Visual Arts and Skills Acquisition

29. M. Adelson, "Creativity and the Third Culture: A University-level Problem." *U.C.L.A. Educator* 18 (1976): 40.

30. See Carl R. Rogers, "The Characteristics of a Helping Relationship." *Personnel and Guidance Journal* 37 (September 1958): 6– 16.

6. The Transformation of the Language of Vision

31. Gyorgy Kepes, *Language of Vision* (Chicago: Paul Theobald, 1947), pp. 8– 10.

32. Rudolf Arnheim, *Visual Thinking* (Berkeley: Univ. of California Pr., 1969), pp. 294– 315.

33. For discussion of the application of a verbal model to the arts and its influence on the Renaissance, see Michael Baxandall, *Giotto and the Orators* (Oxford: The Clarendon Pr., 1971). Another good discussion of the verbal nature of Renaissance-based art is Jose A. Arguelles, *The Transformative Vision* (Berkeley: Shambhala Publications, Inc., 1975).

34. For a discussion of Picasso's early life and career, see Josep Palau i Fabre, *Picasso en Catalūna* (Barcelona : Ediciones Poligrafa, S.A., 1966), pp. 14– 47.

35. *Ibid.,* p. 40.

36. Georges Clemenceau, *Claude Monet: cinquante ans d'amitie* (Paris: La Palatine, 1965), p. 22, as translated in Linda Nochlin, *Realism* (Baltimore: Penguin Books Inc., 1971), p. 63.

37. Comment about this painting and reactions to its exhibition are found in Kermit Champa, *Studies in Early Impressionism* (New Haven: Yale Univ. Pr., 1973), plate 8 and p. 9; and Steven Z. Levine, *Monet and His Critics* (New York: Garland Publishing, Inc., 1976), p. 9.

38. Eveline Schlumberger, "Les impressionistes paintres du bonheur mais de quel bonheur?" *Connaissance des arts* 263 (January 1974): 57.
39. A biographical study of Monet which focuses on his and Camille's relationship is Charles Merril Mount, *Monet* (New York: Simon and Schuster, 1966).
40. William C. Seitz, *Claude Monet* (New York: Harry N. Abrams, Inc., 1960), p. 44.
41. Jose A. Arguelles, *Charles Henry and the Formation of Psychophysical Aesthetic* (Chicago: Univ. of Chicago Pr., 1972).
42. For discussion of these ideas, see Sixten Ringbom, *The Sounding Cosmos: A Study in the Spiritualism of Kandinsky and the Genesis of Abstract Painting* (Helsinki: ABO Akademi, 1970); and R. P. Welsh, "Mondrian and Theosophy," in the exhibition catalogue *Piet Mondrian 1872–1944* (New York: The Solomon R. Guggenheim Museum, 1971), pp. 35–51.
43. John Elderfield, "The Paris-New York Axis: Geometric Abstract Painting in the Thirties," in the exhibition catalogue *Geometric Abstraction: 1926–1942* (Dallas: Dallas Museum of Fine Arts, 1972).
44. W. Sherwin Simmons, "Kasimir Malevich: The Transformed Self— Part I: Cubism and the Illusionistic Portrait," *Arts Magazine* 53 (October 1978): 116–25.

7. On the Relationship of Architecture and Medicine

45. Christopher Alexander, et al., *A Pattern Language* (New York: Oxford Univ. Pr., 1977) second in a trilogy, all of which present the above point of view. The others also by Alexander and Oxford Univ. Pr. are: *The Timeless Way of Building* (1979), and *The Oregon Experiment* (1975).
46. Francisco Varela, a biologist with the Univ. of Colorado School of Medicine, believes the immune system to be cognitive, like the nervous system, with the ability to inhibit and activate its own processes. For a brief review of his work and further references see, "New Model Sees Immune System as Cognitive Process" in *Brain/Mind Bulletin*, vol. 3, no. 6, 6 Feb. 1978. For an intelligent layman's view of the issue, read Norman Cousin's moving personal story, *Anatomy of an Illness* (New York: Norton, 1979).
47. See "The Arts Versus Angus Duer, M.D." in this volume for a reasoned argument by John Cody, countering the first two of these assumptions.
48. Thanks to Eugene Kupper, Professor of Architecture at UCLA, for coining this clarifying phrase in one of many valuable personal conversations.
49. Current literature on lateral specialization of the brain is vast. Two of

the clearest (although older) summaries are: Joseph Bogen, "The Other Side of the Brain, I, II, III," in *Bulletin of the Los Angeles Neurological Societies* 34 (May, July, September 1969); and "The Two Sides of the Brain," chap. 2 in Robert Ornstein, *The Psychology of Consciousness,* 2d ed. (New York: Harcourt, 1977), pp., 16–39.

50. See Rudolph Arnheim, *Visual Thinking,* (Berkeley: Univ. of California Pr., 1969); and Robert E. McKim, *Experiences in Visual Thinking* (Monterey, Calif.: Brooks/Cole, 1972).

51. I am indebted to Robert McKim for the concepts of "clarity" and "control" in *Visual Thinking.*

52. For a more complete discussion of the generic qualities of imagery, see my "On Understanding Awareness," in the *Journal of Aesthetic Education* 4 (October 1970): 74–78.

53. J. Krishnamurti, in his writing and teaching, has been unrelenting on this point for the last fifty years. A recent sample from *The Wholeness of Life* (New York: Harper, 1979), pp. 202–3, follows: "The other kind of learning—to which one is not quite so accustomed because one is such a slave to habits, to tradition . . . , is to observe without the accompaniment of previous knowledge, to look at something as though for the first time, afreshIf one can observe or watch the other without the interference of previous knowledge, one learns much more. The most important thing is to observe; to observe and not to have a division between the observer and the observed."

54. For a discussion of the concept of cognitive distancing, see again, Rusch, "On Understanding Awareness," pp. 63–66. For the original source, see Heinz Werner and Bernard Kaplan, *Symbol Formation* (New York: Wiley, 1963).

55. For a description of a series of such events, read "The Hidden Dimension in Sports," chap. 2 in George Leonard's *The Ultimate Athlete* (New York: Avon, 1977), pp. 33–52.

56. An excellent, clear discussion of the difference between attention and concentration appears in J. Krishnanurti's *Think on These Things* (New York: Perennial Library, 1970), pp. 164–67.

57. McKim, *Visual Thinking,* chap. 6, entitled "Relaxed Attention," has one of the best descriptions I have seen for achieving just the right amount of relaxation to maximize attention in the ways I have discussed. Furthermore, the essay includes exercises with which to practice this relaxation.

8. A Grain of Sand

58. *Blake* (New York: Pitman Publishing Corp., 1949).

9. Among Other Things, Art

59. Duane Preble, *Man Creates Art Creates Man* (New York: Harper, 1973), p. 7.
60. Elting E. Morison, *Men, Machines and Modern Times* (Cambridge, Mass.: M.I.T. Pr., 1966).
61. Erwin Panofsky, *Meaning in the Visual Arts* (Garden City, N.Y.: Doubleday Anchor Books, 1955), pp. 1–2.
62. John Cody, "The Arts Versus Angus Duer, M.D.," published in this volume.
63. Raymond Aron, "The Epoch of Universal Technology," *Encounter (Pamphlet 11)*.
64. Rene Dubos, *Man Adapting* (New Haven and London: Yale Univ. Pr., 1965), pp. xix–xx.
65. Report of the Citizens on Graduate Medical Education, *The Graduate Education of Physicians* (Chicago: American Medical Association, 1966), p. 11.
66. Jerome S. Bruner, *On Knowing: Essays for the Left Hand* (New York: Atheneum, 1965), p. 63.
67. Howard S. Becker et al., *Boys in White* (Chicago: Univ. of Chicago Pr., 1961).
68. William Walsh, *The Use of Imagination* (London: Chatto and Windus, 1964), p. 53.
69. *Ibid.*, p. 54.
70. Bruner, *On Knowing*, p. 63.
71. Samuel Taylor Coleridge, *Biographia Literaria* (London: J. M. Dent & Sons, Ltd., 1949; originally published in 1817).
72. Walsh, *The Use of Imagination*, pp. 52 ff.
73. E. A. Vastyan, "Humanities in a Medical Curriculum: An Experiment," *Pennsylvania Journal of Medicine* 71 (1968): 78–81.
74. Walsh, *The Use of Imagination*, p. 22.
75. Steven E. Klot, "The Visual Arts at Hershey: A Year's Assessment." Manuscript, 30 June 1977.
76. Bruner, *On Knowing*, p. 6.
77. J. E. Bogen, "Some Educational Aspects of Hemispheric Specialization," *UCLA Educator* 17 (1975): 24–32.

Notes on Contributors

ERIC AVERY—artist, photographer, and psychiatrist—completed his residency in psychiatry at the Psychiatric Institute in New York, specializing in geriatrics. After working on several photographic projects at major medical institutions to document and explore the "space" of art and medicine, he now works as an artist in the Southwest.

GERI A. BERG—art historian and social worker—was formerly co-chairperson of the Program on Humanistic Studies at Johns Hopkins University School of Health Services in Baltimore, Maryland. Ms. Berg is interested in ways that art explores, expresses, and values human experience and in the relevance of art for technical and professional education. She lives in Portland, Oregon, where she is a social worker on an outpatient health care team serving handicapped children and their parents and is a national consultant on art, humanities, and medical education.

JOHN W. BURNSIDE—physician—is chief of the Division of Internal Medicine at the Hershey Medical Center. Both a teacher and a clinician, Dr. Burnside has written a textbook on physical diagnosis and is interested in nonquantifiable, humanistic skills used in assessment and treatment of patients.

JOHN CODY—psychiatrist—was graduated from the Johns Hopkins Medical School, Department of Art As Applied to Medicine, worked as a medical illustrator for the New York Zoological Society, and later served as director of the Medical Illustration Department at the University of Arkansas. After medical school he completed his psychiatric training at the Menninger Clinic. Dr. Cody published *After Great Pain, The Inner Life of Emily Dickinson*

(Harvard Univ. Pr., 1971) and is working on a full-length psychological portrait of Richard Wagner.

CHARLES W. RUSCH—architect—teaches at the University of Oregon, where he is head of the Architecture Research and Design Unit. Mr. Rusch was formerly head of the Department of Architecture and Urban Planning at the University of California, Los Angeles, where he taught courses in visual thinking and cognition. He is interested in root assumptions in professional fields which impede effectiveness in serving people. Examination of such assumptions in education led Mr. Rusch to found a school for his own children that is still operating in Los Angeles.

W. SHERWIN SIMMONS—art historian—completed his doctoral work at the Johns Hopkins University on the early twentieth-century Russian abstract artist Kasimir Malevich, and has published several articles on this artist. A faculty member in the Department of Art History at the University of Oregon, Dr. Simmons is interested in the languages of art and medicine and how they define and limit perception and activity in each field.

E. A. VASTYAN—medical educator—has been engaged in medical education for twenty years, and has been head of the Department of Humanities at the Hershey Medical Center since its founding in 1967. He studied literature under a Fulbright Fellowship at the University of Southhampton, England, and received his theological degree from the Episcopal Theological School in Cambridge, Massachusetts.

BERNICE M. WENZEL—medical educator—is interested in innovative forms of instruction, techniques, and procedures of improving medical education. Dr. Wenzel is a member of the Department of Physiology at the University of California, Los Angeles, and holds a joint appointment in the Department of Psychiatry.

Index